The Painter's Corner

OILS

BARRON'S

OILS

Original title of the book in Spanish:
El Rincón del Pintor: Óleo
© Copyright PARRAMÓN EDICIONES, S.A.—World Rights
Published by Parramón Ediciones, S.A., Barcelona, Spain

Author: Parramón's Editorial Team
Illustrator: Josep Torres
Text and Coordination: David Sanmiguel
Exercises: David Sanmiguel, Josep Torres, and Yvan Vinyals
Photography: Nos & Soto

Translation from Spanish: Michael Brunelle and Beatriz Cortabarria

Acknowledgments

Parramón Ediciones, S.A. would like to express its gratitude to the art supply store Casa Piera and to the following companies for their kindness in making their painting supplies available to us:

Talens
Titan
Pinceles Escoda

Table of Contents

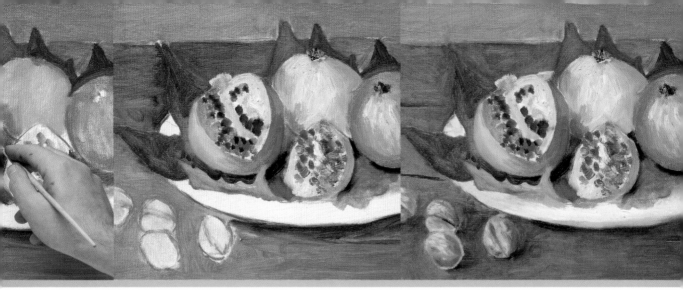

Introduction

Oil painting is universally regarded as the most noble of the artistic mediums. It is usually also considered as the most difficult technique. Of course, there is a basis for argument on both claims, but there is no doubt that the most acclaimed works among western paintings are done with oils. It is from these works of art that the prestige of oil painting is derived. As far as the difficulty of its use, oils are not any easier nor more difficult to apply than any other medium. In art, it is all a matter of acquiring enough practical experience, and this book is a complete guide that will provide that valuable experience to the reader.

As far as technique, the first section of this book is devoted to the review of the techniques of some of the great works of art from the past. You will see that the great masters did not limit themselves to accepting the methods from the past; they opened new paths and created new ways of applying materials. It is through the works of these great creators that the reader will be able to submerge himself or herself in the passionate world of creative painting.

If we pay attention to the concrete and real differences, we will see that oil painting requires quite a few more tools than watercolors or pastels. Also, it takes longer for this medium to dry, and its treatment requires patience and energy at the same time. These are its essential characteristics, and problems may arise if we try to use oils in a way different than their nature dictates. We have devoted one section for a detailed explanation of the materials and tools needed to paint with oils, and the most appropriate ways of using them. These explanations are accompanied by recommendations and cautionary advice to avoid errors. The last two sections of the book cover the techniques for working with oil paints, from the structured modeling to the freer and more spontaneous approaches. By following the explanations and the sequencing of the photographs, the reader will acquire an insightful understanding of the characteristic processes.

In brief, this book offers a complete overview for painting with oils, and at the same time it provides an easy introduction that is as valuable to the professional painter as to the novice.

A Brief History of Oil Painting

The history of oil painting is an admirable succession of innovations brought on by the great artists of European painting. Their work shows that this medium is the most versatile of the artistic expressions.

Oil painting, compared to other artistic procedures, is quite a recent medium, only barely 600 years old. Not much if we compare it to ink, which was already used by oriental artists 2,000 years ago, or to watercolors, whose use was commonplace in Ancient Egypt more than 5,000 years ago. But the greatest difference lies in a decisive factor: oil painting has been the medium of expression of the great masters of European painting from the Renaissance to present time, and it has also been the most important tool for the incredible evolution of the art of painting.

Through the last six centuries, oil painting has been used in thousands of ways: from the enameled surfaces of van Eyck, to the Impressionists' canvases, which were full of thick and rich brushstrokes, through the heavy layering of Titian, the subtlety of Velázquez, the luminous effects of Turner, the naturalism of the

Oil painting has been the medium of expression of the great masters of European painting.

history painters of the nineteenth century, and so forth. The list of references is endless, and it proves that this has been the most versatile medium of artistic expression of all time.

Oil paint adapts to every style, and it lends itself to techniques that can be either delicate or energetic, refined or crude, opaque or transparent. Its possibilities seem to be endless. This very brief historic review will cover some culminating moments in the evolution of this technique, through the study of important works of art from different moments in its development. The roster of artists presented in this book is very short and very subjective. We could have chosen other equally important artists, but one thing is certain, that the masters gathered here were great creators in their time, who contributed to the universal prestige that oil painting has today.

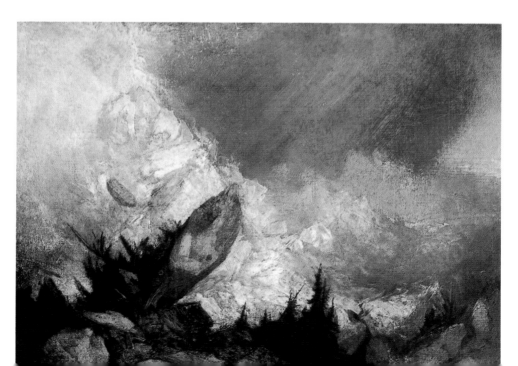

W. Turner, The Avalanche. *Tate Gallery, London. Turner was one the greatest innovators of the oil painting technique. His inspiration always came from the most spectacular natural phenomena.*

From Tempera Painting to Painting with Oils

It is difficult to know when oil painting made its appearance, but there is no doubt that it happened after the year 1400, and that it took place in Flanders, a country that in those days included the present-day Belgium and Holland. Until then, the painters, when they were not doing frescoes, had worked on wood instead of canvas, and they used a paint with an egg yolk base, called tempera. Jan van Eyck (1422–1441) was the founder of the Flemish school, and the first great artist to use oil paint, which he had perfected himself. He started with an oil base whose drying process was relatively slow, which allowed him to mix colors easily, and to work on detail with more precision than with the old tempera. The work of art reproduced here displays the incredible detail and delicate surface that van Eyck achieved with his new procedure.

Jan van Eyck, Wedding Portrait. *The National Gallery, London, Great Britain. Not only is the masterpiece one of the first examples of the oil painting technique, but a display of the technical mastery and creative sensibility beyond compare.*

THE VIRTUES OF OILS
Little by little, van Eyck's example was adopted by all the Renaissance painter's and those that followed. Even those most reluctant to use them had to admit that oils were more malleable and resistant than traditional procedures and also allowed the use of multiple layers.

The old tempera did not allow representations of the color subtleties produced by light on the objects. Oil paint on the other hand, offered the possibility of depicting the color of the flesh with total realism.

The surfaces of the objects are represented with different treatments. Metal, glass, wood, etc. are painted according to their particular texture.

With the arrival of oil paint, the painter was able to represent every shade and gradation of light and shadow. The color darkens progressively, without abrupt changes in tone, and all the subtleties blend with one another.

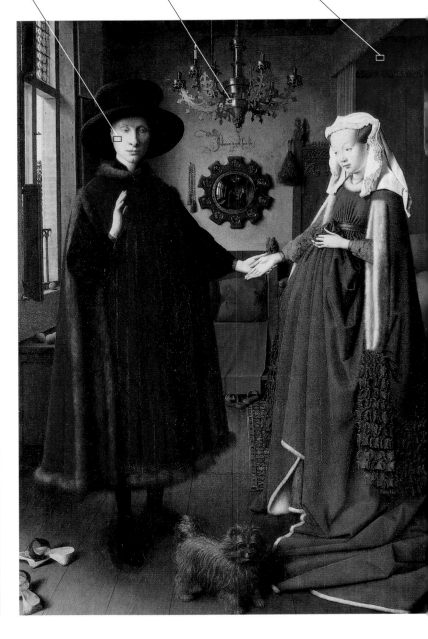

Old Working Methods

The painters who used tempera, as well as the first painters who created with oils (sometimes they combined both procedures on the same painting), worked in a very structured manner, leaving little room for improvisation. First, they made a complete line drawing, where they included all the details that they later filled in with base colors. Lighter objects had a whiter base. The backgrounds were prepared using a base with a uniform color. To make the color of flesh, they first spread a greenish or light gray as a base. This method always resulted in a clear and well-defined look.

Before the color was applied, the areas reserved for the flesh were painted with a gray-green color (known as verdaccio*), which served as a neutral base for the soft tones of the figures' skin, which was painted with glazing.*

The hair was painted directly on the white surface. Painting on a board, like this one, the white was prepared using a base of glue and gesso. The white surface contributed to the great luminosity of the color.

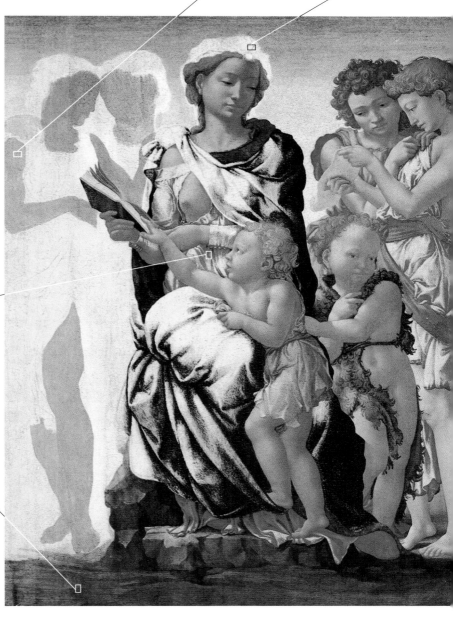

Michelangelo, Madonna with Child, Saint John, and Angels. *The National Gallery, London, Great Britain. This is an unfinished painting done with tempera. It allows us to understand the method that was also used by the first oil painters. The work was drawn in great detail, and the color was applied by areas that were clearly defined.*

The clothes were done over a white background. This way, the artist was able to precisely control the areas of light and shadow, progressively darkening the grouping according to the specific guidelines of the drawing.

The ground was treated conventionally. Normally, rocks were painted, and a coat of lightly tinged brown color was applied to suggest the irregularities of the terrain. Some blades of grass, and other trivial details were added over this base.

The Nobility of the Technique

After some time, painters left behind the meticulous techniques of tempera painting, and began experimenting with oils to invent new methods of expression. From the mid-fifteenth century on, most great artists used oils in their paintings, and they abandoned wood surfaces in favor of canvas. The latter is much lighter and it allowed them to work in larger formats, which were previously reserved exclusively for murals. Beginning with Titian (1487–1576), oil painting reached its maturity. This great master painted over canvases prepared with an ochre or red tone, drawing with the brush tip, without detail, allowing the brushstroke and the texture to give the subject matter vitality and expression.

Titian, Tarquino and Lucretia. Gemäldegalerie der Akademie der Bildenden Künste, Vienna, Austria. A masterpiece from Titian's later years, when the artist had total mastery of oil painting and used a surprisingly loose style.

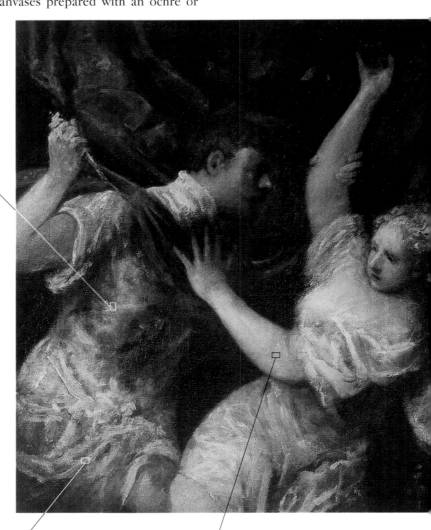

Titian's mastery in the handling of oils is evident in the way he achieves the representation of the metallic glossiness of the breastplate, by using loose strokes of shading that lets the light ochre tone of the background show through.

PICTORIAL STYLE
Titian began using what is known as "pictorial" painting, a style of painting based on color, shading, and brushstrokes, rather than in the meticulous and imitative treatment of the subject matter. This is the style that will be adopted by all the great painters of the Baroque period, from Velázquez to Rembrandt, continuing with Rubens and Frans Hals, and extending to Goya, and finally to the Impressionists, as well as the present-day artists.

Titian discovered the power of a pure brushstroke, a brushstroke that does not surrender to the detail of a preliminary design, but that improvises the shape with a quick movement, leaving behind lumps and layers of textured color.

The tone of the flesh is nothing more than the color of the background, touched up slightly with a red or greenish glaze (a layer of transparent color) to indicate the areas of shadow.

Power and Glory

During the Baroque period, oil painting became almost the exclusive medium used by painters, and was the favorite of the great European nobles and monarchy. Rubens worked for the principal royal houses of Europe, expressing himself in a sumptuous style, full of movement and brilliant colors. In Rubens (a famous Flemish painter) can still be seen the influence of the traditional style introduced by van Eyck, but he handled the oils in an expansive way, and with colors that were full of beautiful shades of color. Thanks to oil paints, artists were able to swirl light, shadow, and intense tones to create spectacular compositions, sometimes of colossal dimensions.

Peter-Paul Rubens, Juno and Argos. The Wallraf-Richartz Museum, Cologne, Germany. Rubens painted grandiose Baroque compositions on canvases of great dimensions, displaying the most diverse technical resources of oil painting.

Rubens was a consummate master of the glazing technique. With it, he made possible the representation of the most diverse atmospheric scenes, from unobstructed midday clarity, to the gloom of the night hours.

In the ornamental details, Rubens adopted a careful and very decorative style, based on the representation of the shininess of silk, gold, and previous material, and by using generous layers of color depicting them.

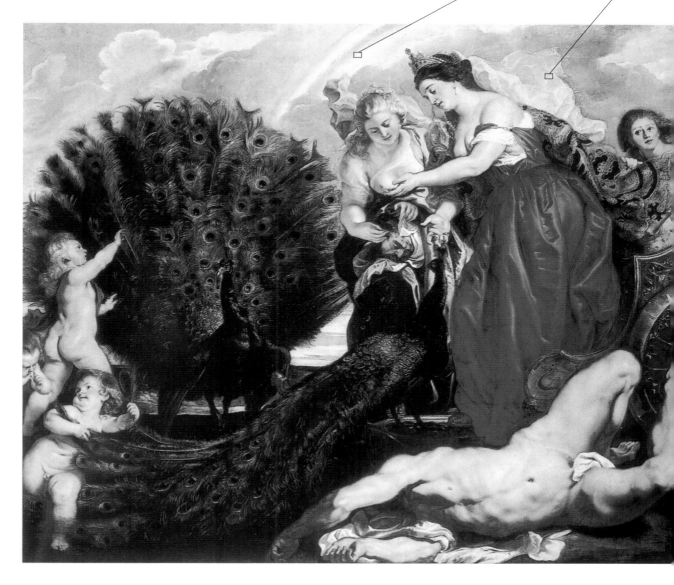

The Craft of the Virtuoso

Oil painting became the artistic medium of preference since painters such as Titian and his followers discovered that with oils they could develop a more personal style than with any other medium; they could also exhibit a brilliant and casual virtuosity technique. This work by Annibale Carracci (1560–1609) is an example of the way Italy reacted to the term *fa presto*, which refers to a type of quick painting. It is a style in which the artist represents the subject matter and the quality with energetic brushstrokes, which, as with Titian, are not concealed with finishing touches. It is a type of painting produced by maintaining the spontaneity of the stroke, the agility and energy of the movement of the brush. A type of painting that, viewed at close range, shows the sensuality and expressive power of oil paint and its colors, and seen from some distance it appears perfectly realistic. Many years later, the Impressionists and the avant-garde artists of the twentieth century will rediscover this technique, using heavy strokes of color.

The shine and reflections of the bottle have been achieved with heavy brushstrokes that allow the black of the background to show between them. These brushstrokes improvise the shape, and it is when they are observed from a distance that they make sense and their function in terms of shine and reflection is understood.

The sleeve has been depicted with total freedom, using quick separated brushstrokes. The black of the background suggests the shadows of the folds. In this detail the brushwork is appropriate for a model or sketch, although the overall effect is that of a perfectly finished painting.

The flesh (color of the skin) has been painted over the black background, using heavy brushstrokes mixed directly on the canvas. Despite the energy of the execution, there is a special sensibility in the drawing and the modeling of the facial features.

The collar of the shirt has been created with quick, white parallel brushstrokes. These lines not only shape this area of the clothing, but they also suggest the quality of the fabric with the texture of the brushstrokes.

Annibale Carracci, Man Drinking Wine. Christ Church Gallery, Oxford, Great Britain.

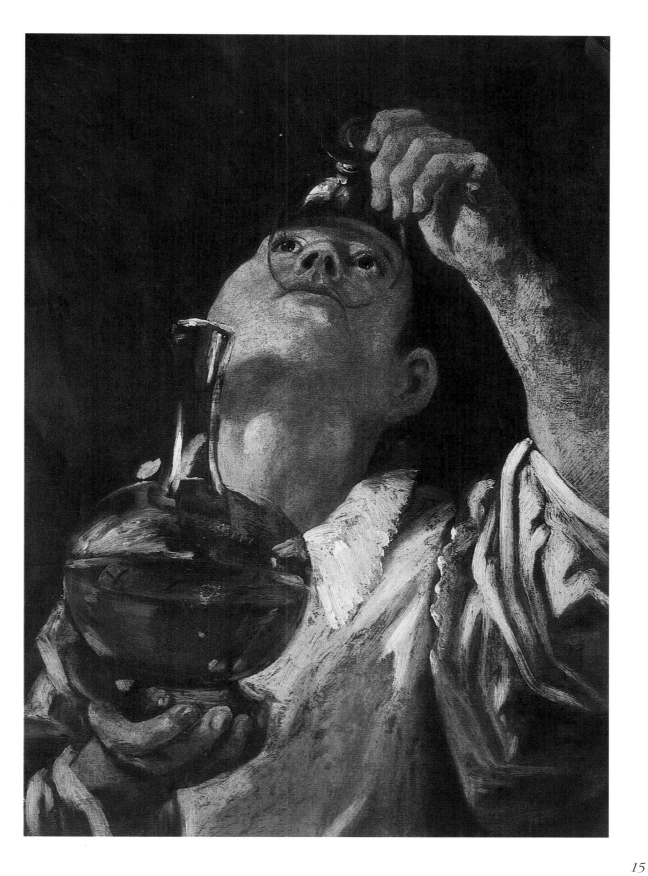

A Passion for Painting

Following the Baroque period magnificence, oil painting still had many unexplored possibilities in store for artists. One of the painters who fought most vigorously to bring new expression to the medium was the romantic English artist Turner (1775–1851). Turner began his career as a watercolorist and a certain influence from this medium can be seen in his oil paintings: luminosity created by glazing areas of very diluted color, etc. But Turner's main achievement was to give oil painting an added dimension, creating colors of a luminosity and richness unknown until then. In the work reproduced in these pages, the painter reaches the artistic pinnacle of his art.

Joseph-Mallord W. Turner, The Morning after the Deluge. *Tate Gallery, London, Great Britain. One of Turner's most famous pieces, where the artist is ahead of his time and foreshadows Impressionism and almost the abstract art of the twentieth century.*

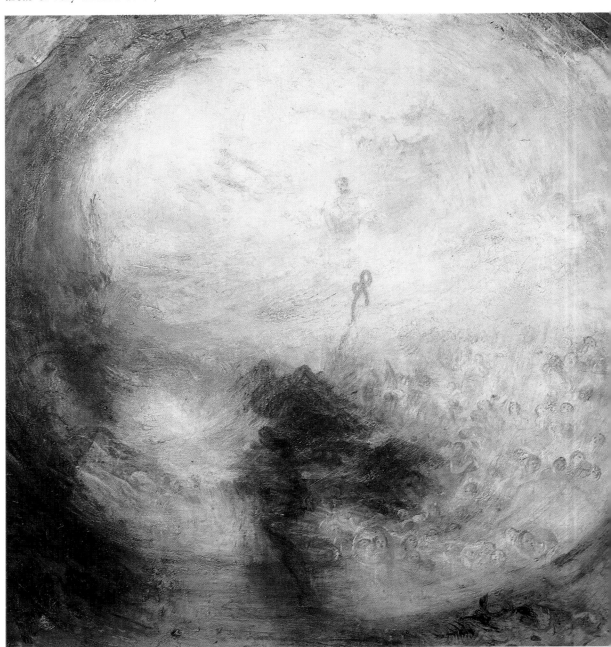

To achieve the maximum luminosity, the painter spread pure white color impastos, highlighting them with blue or yellow tones by scratching with the palette knife or by superimposing fluid brushstrokes after the surface had dried well.

The Palette Knife Makes Its Appearance

Up to Turner's time, the palette knife had been an auxiliary painting tool, which was used to stir the paint in the containers or to apply it to specific areas. Turner used it as much as the brush, to extend the color, and to mix it on the canvas, to scrape and correct, to create textures and impastos, etc. The result is impossible to replicate with any other tool. The palette knife is not good for details and requires mass applications, treating the canvas as a whole without any well-defined areas. This method is what many artists use today.

The texture of the color and thick areas are created with the palette knife, which spreads the paste and produces crevices and texture marks that make the surface of the painting much more interesting.

In this work, the details of the forms are suggested rather than finished. The figures are created using blocks and lines of the same color, which allows the tone of the background to come through in such way that the atmospheric unity is not destroyed.

Turner superimposed several layers of very diluted color. This way, he created chromatic glazing, which suggests the light, the glossiness of the water, the mist, and the most typical effects of a romantic landscape.

EFFECTS OF LIGHT AND COLOR
Turner was the first artist to use oils exclusively to create a type of atmosphere. Thanks to this medium, form can become secondary to allow the glazing, texture, and luminosity effects to create all the expression. Oil paints lend themselves to many technical developments and Turner achieved some of the most daring ones.

A New Realism

Beginning with the French Revolution, artists no longer worked for the king or the pope, and the bourgeoisie became their clients. This incipient bourgeoisie required realistic and truthful representations and the painters adopted detailed styles in which drawing once again dictated the distribution of color. Tones became delicate and very refined, and painters such as the Neoclassic J. L. David (1748–1825), who painted the portrait shown on this page, handled oils in an extraordinarily delicate manner, paying careful attention to the contrast of textures in objects. This criteria still has to this day many followers among portrait artists.

PASTEL COLORS

The favorite palette of Neoclassic artists and the majority of portrait artists of the nineteenth century, was pastel tones. They received this name because they were reminiscent of the colors typical of pastel painting, which started to become popular among painters at the end of the seventeenth century. They create very harmonious tones, with no contrasts that are too dramatic, and without the harsh effects of chiaroscuro.

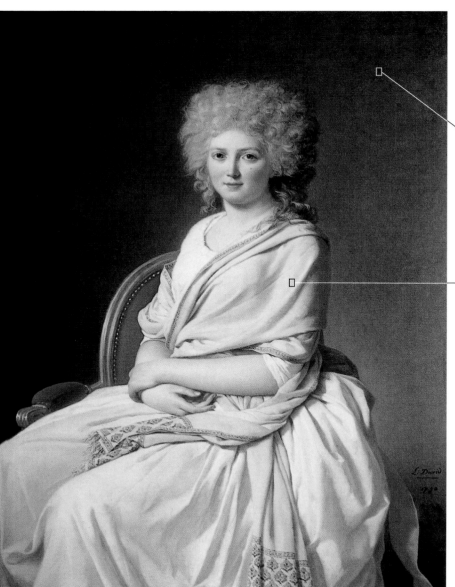

Jacques-Louis David, Portrait of Ana-María-Luisa Thélusson, Countess of Sorcy. *Alte Pinakotek, Munich, Germany. A rigorous work of art in its drawing, and very calculated in its use of color, which presents no impastos or texture effects.*

To focus the attention of the viewer exclusively on the figure, the background was created by dragging the brush, which produced a smooth transition from dark to light. The color is neutral and does not have strong contrasts.

The modeling of the folds is softened to avoid the harsh effects of chiaroscuro. This way the entire figure maintains a light tonality that goes from white to light yellow to the ivory tones of the flesh.

CREATING HARMONY WITH FEW COLORS

The harmony of a painting becomes more grounded and coherent if the colors that are used in it are reduced to a range made up of a few tones. Neoclassic artists always used very limited color palettes.

Historical Painting

The favorite genre of the Realist painters of the nineteenth century was historical paintings. They are representations of legends, scenes taken from literature, of mythology or the painter's imagination, populated by characters and a large variety of accessories. This genre was considered the noblest of all. Artists such as Holman Hunt (1827–1910), painter of the work shown on this page, created exceptional colors, never before seen, thanks to the great development of the chemical industry of the time, which gave painters many new colors. Although with time some of these new tones suffered disastrous effects (darkening, detachments, cracks, etc.), works such as this one still maintain a great chromatic interest to this day.

Hunt used a very particular technique: he painted on a surface of wet paint, which he extended by areas. The tones superimposed on that surface blended partially with it, creating effects of great realism, as can be observed in the representation of this velvet.

The colors were applied with short brushstrokes, using a brush that was not very thick. The resulting effects are areas of color shading that are never completely even.

The love for detail is characteristic of historical painters. Here, the artist has taken the time to paint even the most minute detail of the fallen leaves, the mushrooms, and the smallest blade of grass.

The embroidery and lace of these fabrics are a showcase of the virtuosity and passion for detail. Here, the artist worked with fine brushes of soft hair, which allowed him to gently blend the brushstrokes, and to reach the farthest corner of the forms.

Thanks to the versatility of oils, many painters achieved a spectacularly realistic representation of the reflections of the burnished metal. In this, Hunt is one of the precursors of hyperrealism of the twentieth century.

Impressionism: New Paths for Oil Painting

Impressionism was a return to nature, to landscape, to atmosphere and light, but above all, it was a new way of understanding oil painting. Impressionist artists did not intend to replicate real objects exactly, but to offer a vision of the theme at a specific time of day; therefore the brushstroke took center stage. The painting was created with heavy strokes, filled with color, which left a very visible mark on the canvas. Also, these artists stayed away from color gradations and blends, because that diminishes the chromatic power of the painting. On the other hand, Impressionists built the painting using the brushstrokes as if they were the pieces of a mosaic. We can see an extreme case of this approach in the work reproduced here. Georges Seurat (1859–1891) painted small dabs of pure color, which at a certain distance gave the impression of being solid colors. This technique was given the name "pointillism," and it later inspired many experiments in avant-garde art.

OPTICAL MIXING

Colors can be mixed on the palette or on the canvas, but there is a third way. Blue, which mixed with yellow makes green, can be applied in small dabs of pure color, together with as many yellow dots. These small paint dots, which appear attractive at a distance, will create the illusion of green, because the eye, unable to tell them apart individually, will "mix" them together. This optical mixing, laborious and methodical, was the system that Seurat adopted for all his work.

This could be an enlarged view of a small fragment of Seurat's painting. The effect is very similar to an image of a print that has been greatly enlarged. The small dots create diverse colors when viewed from far away.

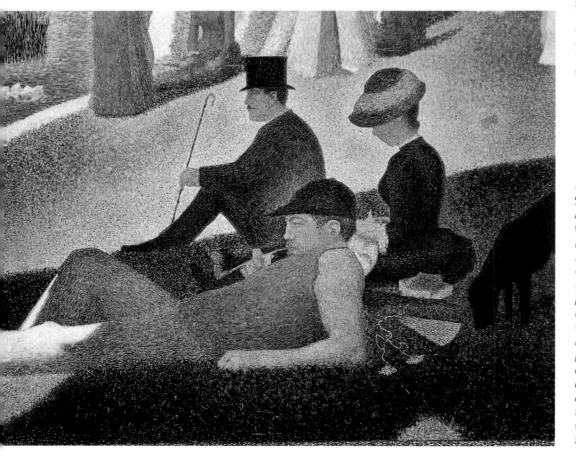

Georges Seurat. Sunday Afternoon at the Grand Jatte (detail). Art Institute of Chicago, USA. All the tones of this painting have been created with groups of minute dots of pure color. The distribution and accumulation of each determines the color effect when viewed from a distance.

A Review of the Materials

New mediums and materials make their appearance on the market every day. Some are improved versions of traditional tools; others are innovations whose worth remains to be proven. Here we will try to offer some criteria for selection.

There is a variety of materials for oil painting. Paints require special solvents, supports, and brushes, which, while not very specific, must have certain characteristics to render them useful. Most of the utensils that we will cover in this chapter are necessary for painting. It is true that there is no rule that we could not paint with just two colors on any piece of paper, using any brush. But the result would never be the same as when the appropriate materials were used. This chapter opens with a curious inquiry into the materials used in different moments of history, which are practically the same that are used today, with few variations. This review of colors, brushes, palettes, canvas, solvents,

We will explain here what materials are really essential, which ones are recommended, and which ones are not needed.

and other accessories does not intend to present an inventory, which is extensive and grows daily, of the implements that the market has to offer, but to advise you on what materials are really essential, which are recommended, and which are not needed. No painter uses all the accessories, and variants that the market offers all the time, because the level of sophistication of the products would require a long period of trial. We are going to limit ourselves to the traditional tools, adding, if needed, some novelty that has been proven to be especially useful, so you can begin painting with oils knowing that you have everything that you need.

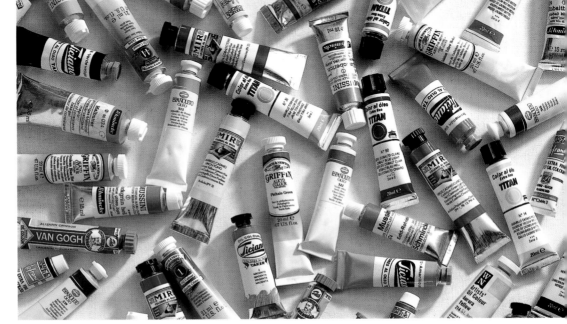

Oil paints need to be applied with specific tools, because only then can maximum performance be achieved.

What Was Used for Painting with Oils 500 Years Ago?

When oil paints first made their appearance, artists worked with very similar materials to the ones used today. The work shown on this page shows the studio of a painter from the sixteenth century. The person represented is Saint Luke, the patron saint of painters, portrayed by a master of the time. He is painting on a wood surface and is holding a small palette on which some colors can be seen. The hand used for painting rests on a stick (called a *mahlstick*), which allowed him to keep a steady hand while working on details. To the left, on a table, a series of brushes of different sizes, a palette knife, and some containers of paint can be seen. To the right of the image, an apprentice prepares the colors for the master. The studios of the Renaissance artists were similar to this one (if not this fancy, equally equipped). Painters had apprentices who crushed the pigments and mixed them with oil to make paint, and the equipment of a painter was not that different from what is used today.

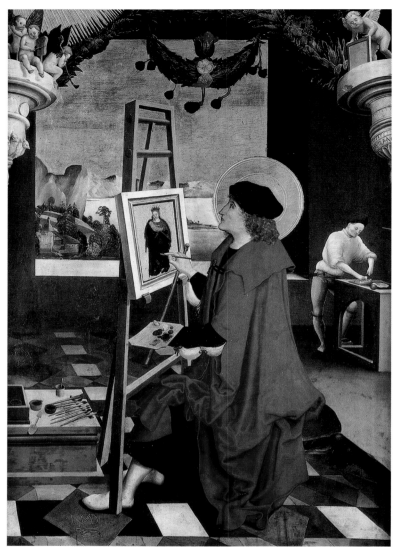

Niklaus Manuel Deutsch, Saint Luke Painting the Virgin Mary. *Kunstmuseum, Bern, Switzerland.*

THE MAHLSTICK

The mahlstick is a wooden stick with a ball at one end (sometimes a piece of cloth wrapped around it) that is used to prevent involuntary movements of the hand from affecting the application of minute details. It is placed touching the edge of the canvas, so the hand can rest on it at the height where the paint is to be applied. It can also be placed directly on the canvas when the artist is working on large formats, if the end is properly wrapped with a piece of cloth. It was frequently used by the classical artists; however, the mahlstick is a tool that is not much used today.

What Was Used for Painting 300 Years Ago?

During the Baroque period and well into the nineteenth century, the tools that the oil painter used were similar to those shown in this painting. The artist holds an oval palette, exactly the same type that is used today. On it we can see an array of colors, similar to those that many artists use today. The way he is holding the palette and the brushes at the same time is also similar. This painter is also holding a mahlstick, while his right hand is engaged in removing paint from a container with a palette knife. On his worktable there are several containers of oil paints. An interesting detail is the canvas, which is stretched over an easel as if it were a pelt drying. When the painting was finished, the artist would loosen the canvas and would mount it on a normal frame, probably similar to modern wood frames.

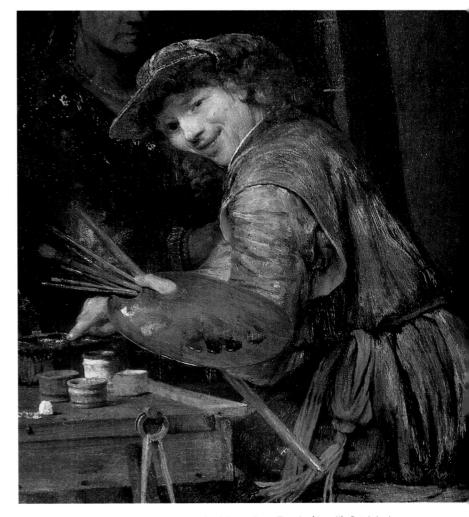

Aert de Gelder, Self-Portrait as Zeusix *(detail). Städelsches Kunstinstitut, Frankfurt, Germany.*

What Is Used for Painting Today?

Fashion has changed, as well as furniture and rooms, but for an artist, the essentials continue to be the same as 500 years ago. Today, a painter's studio must have an easel, a chair, and a side table for the tubes of paint, rags, and solvents. The canvas is sold already stretched on a frame, and there is no need for assistants to make the colors that we need. To all of this, we must add that the artists from the old days did not have electric light. But the basic materials have not changed. Today, we still use a palette, different brushes, palette knives, and, if we choose, a mahlstick.

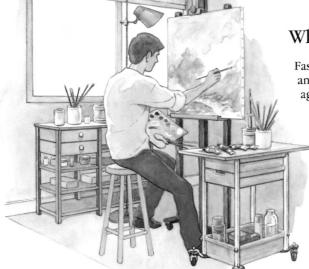

This could be the studio of any modern oil painter.

What Are Oil Paints?

Oil paints are made of pigments and oil. Pigments are substances that give color to any type of artistic medium: watercolors, pastels, acrylics, or oil paints. They consist of organic or synthetic matter finely ground and turned into powder. Oil is added to this substance and it is bound with it until a paste is formed, which is known as oil paint. The oil could come from many sources (from poppies, from walnuts, etc.), but linseed oil or a mixture in which it dominates is normally used. The quality of the pigments, their concentration, and the correct binding with the oil are basic factors that determine the quality of the oil paints.

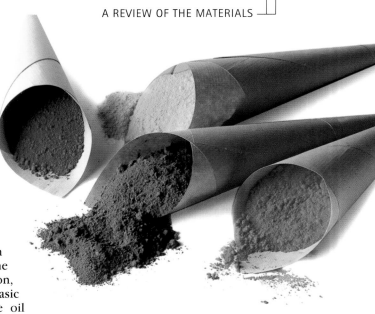

The basic material of oil paints is the pigment, which can be organic (soil, ground minerals, etc.), or synthetic. They must be finely ground to be suitable for making colors.

Preparing Colors in the Studio

Although only few artists prepare their own colors, it is interesting to know the artisan's method for making oil paints. A shiny surface should be used (marble or glass) to place the pigment on. A small amount of oil is poured over this, and the artist begins to make the paste using a marble or glass muller with a wide base, pressing with it constantly while moving it in circles. It is better not to add too much oil, or it will float to the top when the mixture is placed in a container. At the end, the paste must have a thick and even consistency, and not have any visible particles on its surface.

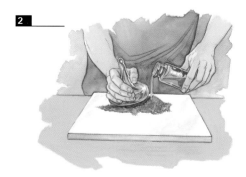

1 Some powdered pigment is placed on a shiny marble or glass surface.

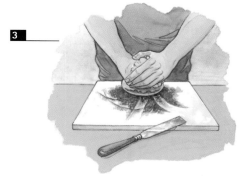

2 A small amount of linseed oil is poured over the pigment. Then, the artist begins to work the paste with the help of a glass muller. After a few moments, if the mixture does not bind well, a little more oil is added.

3 Once the paste has thickened, the mixture should continue to be worked. Little by little it becomes more fluid. The process is completed when the appropriate fluidity is achieved and there are no unbound particles.

Oil paints prepared by hand have a high probability of containing excess oil. Ideally, when the paste has acquired the perfect consistency, it is put away for about six months to let the oil rise to the surface, at which time it can be removed.

The Quality of Paints

Premium-quality oil paints are very expensive, as they must be. To achieve their perfect manufacture, in addition to using the best pigments (some of them very expensive) and the most refined oils, the paste must be left to settle for a minimum of six months to allow the excess oil to float to the surface so it can be eliminated. With the exception of very few specialized brands, the majority of the manufacturers cannot be so scrupulous if they want to commercialize oil paints at reasonable prices. In practice, medium-quality paints are perfectly suitable for the amateur and professional alike. Sometimes they exude oil when the tube is opened, but if this happens, simply leaving the paste on a piece of newspaper for two or three days will eliminate the excess oil.

WHY DO SOME TUBES OF OIL PAINT WEIGH MORE THAN OTHERS OF THE SAME SIZE?

You may have noticed it yourself: two similar tubes of different color paint have a slightly different weight. This is normal. It is due to the fact that some pigments saturate the mixture with oil earlier than others. In other words: the same volume of oil holds more of a certain type of pigment than others. Naturally, the tubes with more concentration also tend to be the most expensive.

Large machines are used in the manufacturing of oil paints. They allow the paste to be mixed with the precise amount of oil, achieving great homogeneity in the mixture. (Photo courtesy of Talens.)

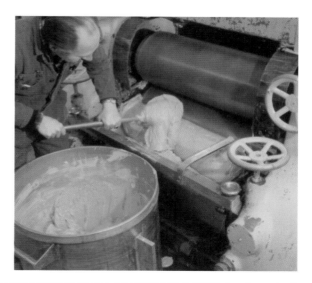

EARLY CONTAINERS

Oil paints have not always been packaged in tubes. The distant predecessors of the modern tubes were leather pouches with a small hole, through which the paste was squeezed out by applying pressure to the bag. This hole was covered with a thumbtack. New methods were tested during the nineteenth century, a system similar to a syringe or a plunger, or a lead tube pierced with a nail. Finally, the Winsor & Newton company found the solution halfway through that same century: a tin tube with a screw-on top. This invention decisively influenced the way artists work, because this allowed them to work outdoors without the inconvenience of the old systems.

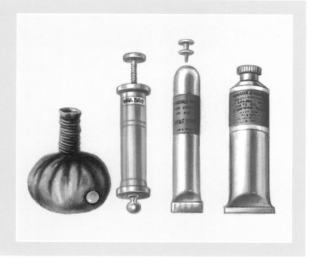

The Painter's Equipment

Below we present the basic equipment of a typical painter. Everything is there except for the canvas, which in medium and large formats cannot fit in the box. It is a great advantage to be able to gather the entire equipment of a painter in a box that is rather small and light. Many types of boxes of various qualities are available; some have small drawers for additional materials, and are made with fine woods, carefully finished with varnish. They can make a wonderful Christmas present, but the truth is that they are not absolutely necessary. The artist can simply purchase an empty box to store different materials, or can buy one that has all the accessories. Avoid the ones that are too small even though they look very manageable; they are not very useful because they tend to fill up quickly and then become unusable. A good box should be medium or large in size, sturdy, and without too many compart-ments inside. An area for the brushes, another for the paints, and a third one for the solvents, charcoal pencils, large tubes, etc., is enough.

THE RIGHT MATERIAL

Do not get carried away by the enormous amount of oil painting materials available on the market, and above all, do not attempt to carry them all in your box. In fact, the fewer the tools the better; there is nothing more tedious than having to remove tubes, brushes, and containers to find the special color that is lost. Everything should be in view and readily available.

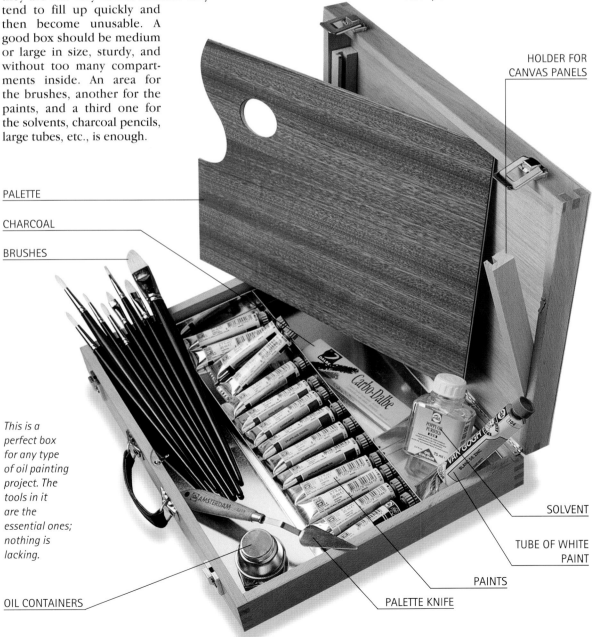

PALETTE

CHARCOAL

BRUSHES

HOLDER FOR CANVAS PANELS

This is a perfect box for any type of oil painting project. The tools in it are the essential ones; nothing is lacking.

OIL CONTAINERS

PALETTE KNIFE

PAINTS

TUBE OF WHITE PAINT

SOLVENT

The Palette

Avoid small palettes; they are good for only a very specific type of painting project. And because the palette cannot be larger than the box, you should look for a medium or large box. Make sure that the palette is properly varnished and is comfortable to hold.

Charcoal Sticks

Most painters begin their projects by drawing on the canvas with charcoal. Therefore it is essential to have a box of charcoal sticks on the palette and to avoid leaving them loose because they are very fragile. They can be replaced or complemented with conventional pencils, lead holders, or charcoal pencils.

Brushes

The brush collection should fit in the box comfortably. We will not cover this subject extensively at this time. The following pages will present the most appropriate brushes.

Oil Holders

These are small containers that are clipped to the palette, and are used to hold the solvent. They are not completely necessary, but it is more comfortable to work with them than with cans, which must be placed on a table or other large surface.

Holder for Canvas Panels

This consists of two folding pieces with vertical incisions where the painting surfaces made of canvas panels can be placed, as illustrated on facing page. They are used for making quick color sketches outdoors, or for painting small formats. This tool turns the box into a true miniature easel.

Painting surfaces of various sizes.

Solvents

The most common solvent in oil painting is conventional or rectified essence of turpentine, but some professionals use a mixture of oil and solvent, or special products such as the ones shown below. In any case, you must make room in the box to hold at least one of these containers.

Tube of White Paint

Painters normally use white more than any other color; therefore, we recommend that you have a large tube of this color available. Depending on the artist's preference, large tubes of any other color used frequently may also be included.

Color Paints

When purchasing the box, make sure that the space reserved for the colors is sufficiently large to hold your favorite selection of paints. The number of colors used with some frequency ranges between 10 and 15. Consider also tube sizes and whether you are going to need several large ones.

Palette Knives

Palette knives can be hard or flexible, long or short, shaped like a knife or a trowel; each one of them has a particular use. The most logical approach is to have a long, flexible palette knife shaped like a trowel, because it is the most useful for any circumstance.

Solvents.

Paints

Oil paints usually come in tubes of three sizes: 2/3 ounces (20 ml), 2 ounces (60 ml), and 6-3/4 ounces (200 ml). Ideally, paints should be purchased in medium-size tubes of 2 ounces (60 ml), except white, as explained on the previous page, and any other color that is used frequently, of which we recommend purchasing the large size of 6-3/4 ounces (200 ml). Most of the well-known companies (Talens, Schminke, Blocks, Winsor & Newton, Titan, or Lefranc, among others) manufacture oil paints of different qualities, and they market the more economical products under a different name. The best-quality paints are identified on their labels, but these varieties are very expensive. It is best to purchase tubes in the medium range of any of the brands listed above. In any case, it is best not to trust those that are very cheap because they offer a quality that is below the minimum standards.

THE TUBE SIZES
Normally, it is sufficient to purchase most of the colors in small or medium-size tubes. Some, like white, are used much more than the others, and therefore it is better to buy them in larger tubes. With practice, you will find out what colors are used more frequently and you will be able to decide exactly what sizes you need to purchase of each tone.

This picture shows all the typical sizes of oil paints. The smallest are not very practical, because they get used up very quickly. It is best to purchase medium sizes plus one large tube of white.

Special Colors

Every day new products are marketed by the paint industry. Alkyd oils are well known among professionals. They dry very fast and they are applied the same way as traditional oil paints. The latest novelty is the water-soluble oils, which dry even faster than alkyds. They are an interesting invention that still has to pass the test of time to prove their durability and their acceptance by artists.

Fast-drying alkyd paints in tubes.

Tubes of water-soluble oil paints, a new creation of the chemical industry. It still remains to be seen if they are completely viable as an alternative medium to the traditional oil paint.

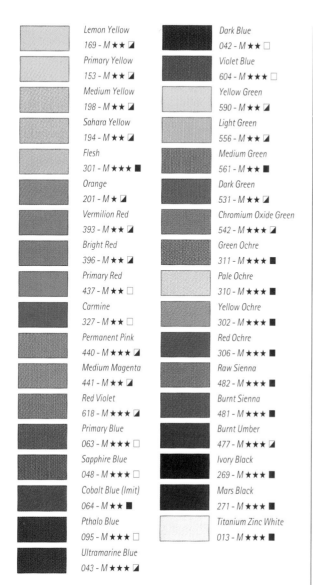

Color chart of oil paints.

★★★ Colors of total stability, even shading
★★ Very solid colors
★ Solid colors used in pure form
□ Transparent colors
■ Opaque colors
◪ Semiopaque, semitransparent colors called neutral
M Colors whose mixture is stable

Lemon Yellow	169 - M ★★ ◪	Dark Blue	042 - M ★★ □
Primary Yellow	153 - M ★★ ◪	Violet Blue	604 - M ★★★ □
Medium Yellow	198 - M ★★ ◪	Yellow Green	590 - M ★★ ◪
Sahara Yellow	194 - M ★★ ◪	Light Green	556 - M ★★ ◪
Flesh	301 - M ★★★ ■	Medium Green	561 - M ★★ ■
Orange	201 - M ★ ◪	Dark Green	531 - M ★★ ◪
Vermilion Red	393 - M ★★ ◪	Chromium Oxide Green	542 - M ★★★ ◪
Bright Red	396 - M ★★ ◪	Green Ochre	311 - M ★★★ ■
Primary Red	437 - M ★★ □	Pale Ochre	310 - M ★★★ ■
Carmine	327 - M ★★ □	Yellow Ochre	302 - M ★★★ ■
Permanent Pink	440 - M ★★★ ◪	Red Ochre	306 - M ★★★ ■
Medium Magenta	441 - M ★★ ◪	Raw Sienna	482 - M ★★★ ■
Red Violet	618 - M ★★★ ◪	Burnt Sienna	481 - M ★★★ ■
Primary Blue	063 - M ★★★ □	Burnt Umber	477 - M ★★★ ◪
Sapphire Blue	048 - M ★★★ □	Ivory Black	269 - M ★★★ ■
Cobalt Blue (Imit)	064 - M ★★ ■	Mars Black	271 - M ★★★ ■
Pthalo Blue	095 - M ★★★ □	Titanium Zinc White	013 - M ★★★ ■
Ultramarine Blue	043 - M ★★★ ◪		

Color Selection

Every company manufactures its own selection of colors represented in an organized catalog known as a color chart. All the establishments that sell fine art products offer their clients color charts from different manufacturers so they can choose the colors that best suit their needs. The number of colors that each company manufactures can range between 35 and 150. Among this variety, some similarities of denomination can be found (those of the colors that are known by the name of their pigments), which do not exceed 20 colors. The rest receive a name of the manufacturer's choice; therefore, it is almost impossible to know the type of color represented by such names as "sapphire blue" or "aqua green." However, all manufacturers are required to include a standard reference number, which indicates exactly the type of pigment that the tube contains. By consulting a special chart the artist can pinpoint the authentic nature of each color. Aside from this indication, every tube presents several symbols on its label with information regarding the durability, resistance to light, and performance of each color.

Oil Paint Sticks

One special form of oil paints must be mentioned: paint sticks. They are a type of large oil pastels or crayons that are handled like a stick. They are mixed directly on the canvas and can be diluted with mineral spirits. They are used especially in mural compositions or in large paintings, and their color selection is not very large.

Oil paint sticks. A variety that has made its appearance recently.

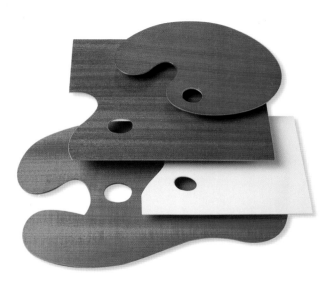

Various oval and square palettes.

The Palette and Its Colors

Palettes are manufactured in wood and plastic; they can be square or oval. Their sizes range from 10 inches (25 cm) long to up to 32 inches (80 cm) long by 20 inches (50 cm) wide for a large palette. As indicated on previous pages, the palette should be neither too large nor too small; it is usually more comfortable if it is made of wood (varnished wood, never raw wood). This is a fine material that acquires a beautiful patina with use. Other than that, there is no additional consideration for using a plastic palette. Shape is also unimportant, but we must point out that for carrying in the box, square palettes provide a larger mixing surface than round ones.

A Palette for Every Need

When we talk about a painter's palette, we are referring to the piece of wood on which paints are mixed, but we could also be talking about the variety of colors that the painter uses regularly. It is quite unusual to find two artists who use the same colors. One of the main characteristics of oil painting is its enormous versatility for mixtures. With just a few colors, a great number of different tones can be created. Each artist masters a limited number of mixing possibilities. A palette comprised of 30 or 40 colors would be almost impossible to handle due to the large number of options that the artist would have available. Therefore, a palette must be chosen: a wood one first, and then one that constitutes the tonal range that will be used.

Distribution of Colors on the Palette

The order of the colors is important because a disorganized distribution makes their mixture uncomfortable. We must get used to a consistent arrangement and use it routinely. Normally the colors are arranged from light to dark (or vice versa), separating the cool tones (blues and greens) from the warm tones (terra-cotta and yellows). White can be placed in a corner or in the middle, between the cool and warm selections.

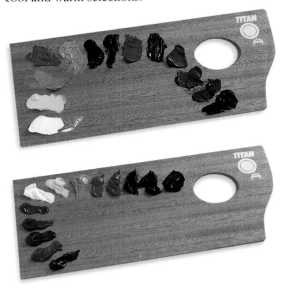

Colors can be arranged from light to dark placing the white at the end of the arrangement, or divided into warm and cool colors with the white placed in the middle of both groups.

DISPOSABLE PAPER PALETTES

There is a wide variety of disposable paper palettes, which consist of a pad of shaped sheets. These sheets of paper are coated with wax to prevent them from soaking up the oil, and they are disposable. When the top sheet is completely covered with paint mixtures, the artist tears it off and continues working on the next sheet, a practical palette for quick projects outdoors.

Using a Palette

When the color arrangement has been decided, the order should always be the same. Upon finishing the work, the palette should be carefully cleaned (see pages 40–41 regarding cleaning and maintaining the tools). But it is interesting to note that many artists clean only the central area of the palette and they leave the colors around it in their places. This conserves paint because what has not been used in one session can be used in the next. With time, the accumulation of paint in their respective areas makes the palette a work of art in its own right. Another way of conserving paint is to save the leftovers gathered after cleaning. The resulting mixture is a gray paste that many painters use as a color or as a primer for the white canvas.

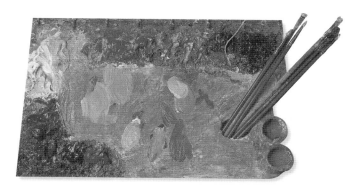

If the palette is large enough, the paints can be left on it after each session, cleaning only the area used for mixing. With time the palette looks like the one in the picture.

Cleaning the palette produces a dirty gray paste. This color can be used by itself or as a gray base to paint a canvas that is going to be covered with similar tones.

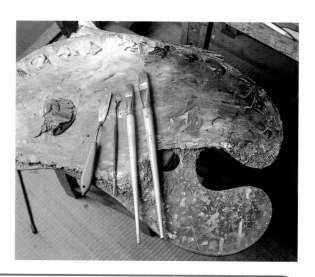

CÉZANNE'S PALETTE

Impressionist artists treated their paints as a chromatic keyboard with which to interpret the changing aspect of nature. We know that Paul Cézanne used a palette made up of the following colors: lead white, bright yellow, Naples yellow, chromium yellow, yellow ochre, red ochre, natural sienna, burnt sienna, vermilion, carmine red, lacquer carmine, Verona green, emerald green, green earth, cobalt blue, ultramarine blue, Prussian blue, and black. It is difficult to imagine a more complete palette . . . and a more difficult one to handle.

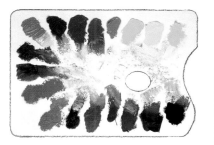

THE CLASSIC PALETTE

Before the arrival of Impressionism, artists used to have a limited palette so they could achieve harmonious colors. In general, landscape painters of the nineteenth century did not have more than ten colors on their palettes. Most of the time these colors included sienna, green, blue, white, and black.

Choosing the Colors

From the many possible combinations, we suggest that you select the colors that will let you handle anything from the most austere subjects to the most colorful. First, titanium white, the most stable and opaque. The best yellows for mixing are cadmium, with an intense and opaque tone; we also recommend lemon or light cadmium. Yellow ochre, an ancient color of excellent quality, should be added to these yellows. Worth mentioning among the reds are vermilion, cadmium red, and carmine. Only the vermilion has some drawbacks: its slow drying time, and risk of turning black. Today, almost every painter uses the other two.

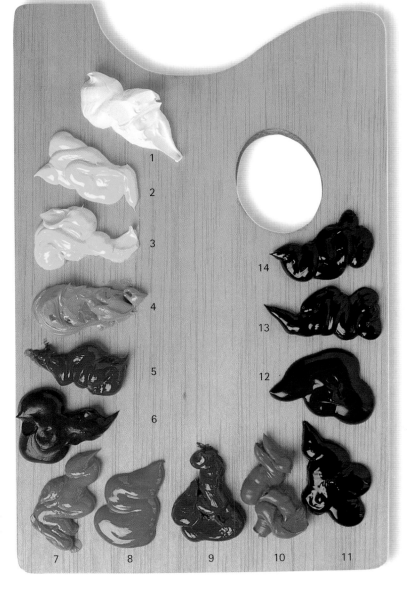

*Our final color selection would be:
1. Titanium white, 2. Cadmium lemon yellow, 3. Medium cadmium yellow, 4. Yellow ochre, 5. Burnt sienna, 6. Burnt umber, 7. Vermilion, 8. Medium cadmium red, 9. Carmine, 10. Permanent green, 11. Emerald green, 12. Cobalt blue, 13. Dark ultramarine blue, 14. Ivory black.*

SUBSTITUTES

Today, most of the colors that are derived from heavy metals such as cadmium, cobalt, or chromium are substituted with less toxic materials of a similar color. The quality of these substitutes is comparable to the original paints, with the added advantage that they are not harmful to your health.

Green, Blue, and Sienna

The greens and blues that are most commonly used are the following: green earth, permanent green, emerald green, cobalt blue, ultramarine blue, and Prussian blue. Cobalt and ultramarine blue come in light and dark varieties. They are stable colors, with few drawbacks, but Prussian blue is very strong and dominates all mixtures, so it must be used with caution. Siennas are also important; burnt sienna and burnt umber are the two most commonly used, but many artists add raw sienna and raw umber, which are darker and more matte. These colors are very stable, and present no problem as long as they are not applied very heavily. The best black is without a doubt ivory black.

The Advantages of Our Color Choices

Our color selection has a number of advantages. First, it includes pure primary colors (yellow, red, and blue), which produce bright results when used for mixing. Second, it has a wide range of sienna colors, which are very useful for creating more muted tones, shadows, and color combinations. And third, the palette is rich enough to use the paint in pure form, without mixing, when working on colorful subjects that require simple and vibrant combinations of color.

Velázquez, Villa Medici Garden in Rome. *Prado Museum, Madrid, Spain. A master example of sobriety, this landscape has been executed with extreme austerity of colors. The gray and greenish tones have been created by mixing; no pure primary color can be found. The result is a work of art with a soft harmony and atmospheric quality.*

Matthias Grünewald, The Stuppach Madonna. *Church of Saint Mary, Stuppach, Germany. The artist used the maximum number of pure colors, and the rainbow in the landscape emphasizes this technique. The harmony is vibrant and expressive.*

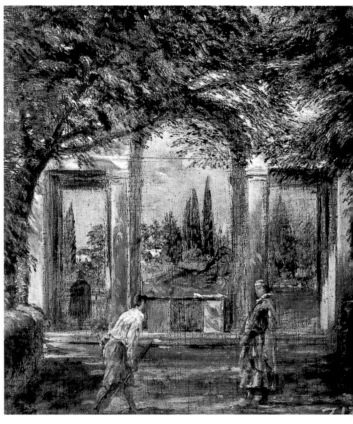

MIXING A LOT OR A LITTLE

The chemistry of paint produces better results if only a few colors are mixed together. If many colors are mixed, there is a greater chance for the chemical components of some of them to affect the color of the resulting tone unfavorably. Although our selection is very stable and the colors are very compatible, excessive mixing tends to diminish their purity. It is always better to aim for tone simplicity than to make elaborate mixtures by adding many different tones.

The Brushes

The brushes most commonly used for painting with oils are hog bristle brushes. Hog bristles actually do come from hogs and are hard and resistant. This hair is a light ivory color and has the best characteristics for oil painting: it holds a lot of paint, it is very good for shading and impastos, and the bristles improve with time. In fact, with use, the fibers of the strands open up, increasing the application capabilities of the brush. But unlike a watercolor brush, which can last for years even if used daily, the sable brush wears out from rubbing on the canvas, and the hair gradually gets shorter until the brush is no longer usable.

On the other hand, first-rate oil painting brushes are considerably cheaper than watercolor brushes of comparable quality. Some artists also use sable hair watercolor brushes. They are very appropriate for doing delicate work, which does not involve impastos, especially for painting lines and details.

Traditional brushes for oil painting are made from hog bristles, which are hard and resistant. Many artists also use soft-hair brushes, similar to those used for watercolors, if the work does not involve impastos but applications of very fluid color.

THE SHAPE OF THE BRUSH

You may have observed that not all oil painting brushes have the same shape. Some are round and end in a point, others are flat, and there are also flat brushes that have the shape of an almond, which can be round or pointed. They all make different lines. Flat brushes create a wide line, and they can be fully charged with paint. Round brushes are better suited for a linear and fluid stroke, and those in the shape of an almond are more versatile, ideal for fine lines and details.

This picture shows all the possible shapes of painting brushes. From left to right: square wash, oval wash, round liners, flat hog bristle, round hog bristle, filbert hog bristle, small filbert, small flat. Above the brushes the characteristic shape of each brushstroke can be seen.

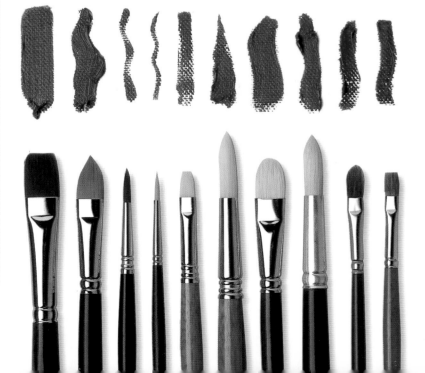

A Set of Brushes

Brushes are numbered according to their size. The numbers usually range from 2 to 25 or 30. A normal set of oil painting brushes must include a variety of bristle brushes. For example, three flat brushes numbers 4, 12, and 20 and three more round ones also made of hog bristles, of the same size. This should be enough, but it would not hurt to add a few small, soft brushes to the list for detailing, and one or two larger brushes for working on backgrounds or for spreading paint on large surfaces. With this set, you will be able to tackle any type of work.

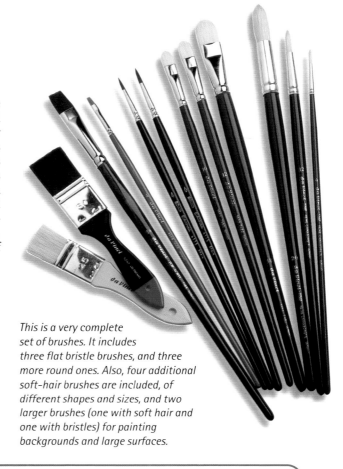

ARE ONE OR TWO BRUSHES ENOUGH?

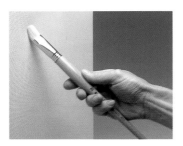

Two brushes are enough for working with watercolors, because they are cleaned by simply rinsing in water. But oil paint does not dissolve so easily, so some brushes must be used only for specific colors. Four or five brushes are the minimum assortment recommended.

This is a very complete set of brushes. It includes three flat bristle brushes, and three more round ones. Also, four additional soft-hair brushes are included, of different shapes and sizes, and two larger brushes (one with soft hair and one with bristles) for painting backgrounds and large surfaces.

HOW TO HOLD THE BRUSH

Oil paint can be handled in many ways, delicately and with attention to detail, as well as briskly and with energy. One single project normally requires all these treatments in each of its stages. The way of holding the brush is crucial for achieving the desired result.

Holding a brush as if it were a pencil results in a calligraphic stroke typical of linear work. Shapes can also be easily defined this way.

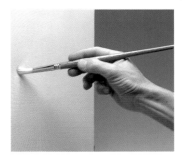

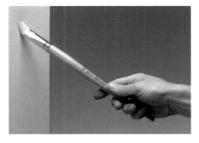

This is the way to hold the brush when creating impastos, that is, painting with thick applications of oil paint.

Holding the brush as if it were a stick enables the artist to paint from a distance, dominating the entire work and applying paint with vigorous but not very precise brushstrokes.

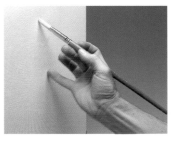

This shows how to achieve maximum line precision. This way of handling the tool is possible when the brushes are small.

Canvas and Other Supports

Canvas is the traditional and most common support for oil painting. The materials used to manufacture canvas are linen, hemp, or cotton thread. Many artists use cardboard and thick paper as bases for sketching and making color studies. However, their excessive absorbency is a drawback because with time they produce imperfections and changes in the color of the paint. Traditionally this problem was solved by rubbing the surface with a garlic clove, which reduced the absorbency. It is also possible to apply glue or gesso primer, which is a paste made of gypsum that seals the painting surface and reduces the absorbency. Any type of cardboard is suitable, as long as it is not too absorbent. But the best alternative to canvas is without a doubt the canvas panels, that is, cardboard to which a fabric suitable for oil painting has been glued. They are light and easy to handle, and they can be taken anywhere in the box. Wood boards, appropriately sealed, make an excellent surface.

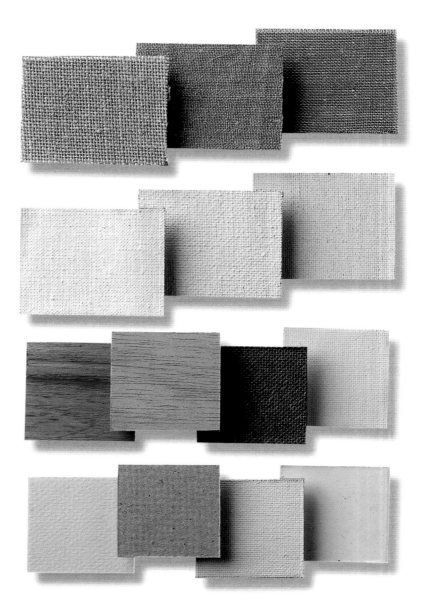

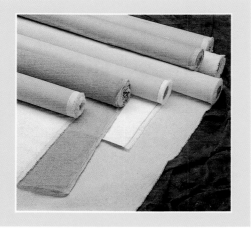

THE QUALITY OF THE CANVAS
The best-quality canvas is made of linen. It is very fine and responds very well in humid conditions as its tension does not change very much with humidity. It is also the most expensive; its price depends on the number of linen threads per square inch of material. There are also fabrics that have a mixture of linen and cotton, to make them more affordable. Cotton fabrics are most commonly used because of their quality-price ratio.

The illustration shows different surfaces suitable for oil painting: canvas, cardboard, canvas panels, and wood. All these surfaces have to be properly sealed to reduce the absorbency.

The Texture of the Fabric

The texture of the fabric depends as much on the material as it does on the preparation or priming of the surface. A piece of high-quality linen fabric offers a very fine texture; therefore, it allows very detailed work. Some artists prefer fabrics with more texture, and some manufacturers offer material made with heavy textures. They are usually expensive fabrics and more suitable for acrylic paints than for oils. Also, the texture of the dry paint on a project that we do not intend to save can be an excellent base for a new project.

The brushstrokes acquire a more textured appearance on a canvas with heavy texture, which makes working on details more difficult.

Priming

The preparation or priming of oil painting canvases is usually based on glue (traditionally, rabbit skin glue) and special white gypsum. The result is a white preparation that has no texture and that reduces the absorbency of the fabric, seals its pores, and constitutes a good base for painting. White started to gain popularity at the beginning of the nineteenth century when the work contained clean and harmonious subjects. Prior to that, the normal approach was to paint on a red surface. Some manufacturers offer gray, tan, or black fabrics. It is possible to purchase fabric that has not been prepared and to have artists apply their own primer. Many artists paint the fabric prior to starting the project with a specific color determined by the subject matter they have in mind and the color harmony that they wish to establish. It is as easy as spreading paint with a brush and letting it dry. In any case, the preparation should withstand the rolling of the fabric without cracking.

Linen canvases have a finer texture, and the color on them acquires a soft and silky appearance.

Incorrect priming produces cracks when the canvas is rolled or folded. Good preparations must be sufficiently flexible to avoid this.

This is the appearance of a canvas that has not been primed. It is impossible to paint on such surfaces because the fabric's pores absorb the paint.

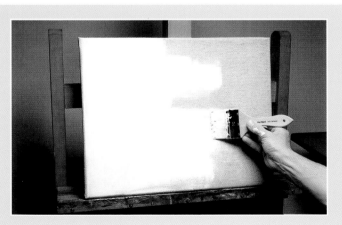

HOW TO PREPARE A SURFACE
To prepare a cardboard or wood surface, a layer of primer (gesso is the most commonly used) must be spread over it. Gesso can be purchased from any art supplier. At least two layers of this should be applied with a flat brush, the second one with perpendicular brushstrokes to the first layer after it has dried. If there are any marks left by the brush, the surface must be sanded with very fine fiberglass paper when it is completely dry.

The Easel

There are two kinds of easels for oil painting: the portable easel for painting outdoors, and the studio easel for painting indoors. The outdoor easel can be collapsed to make it portable. The studio easel, on the other hand, is very solid and stable and is larger. It is important to have a good easel for working on large and small formats, and that will not move while painting. The professional studio easel is mounted on a base supported by four wheels; it is adjustable and holds the canvas firmly. The outdoor easel can also be sufficiently sturdy to use with most of the formats in the studio as well as outdoors, with the added advantage that because it is collapsible, it hardly takes up any space when the session is over.

Solvents

A special solvent is needed to add fluidity to the oil paint. The most common is essence of turpentine, a solvent derived from natural resin, but many painters substitute a more affordable variety, mineral spirits, which comes from petroleum. Turpentine and mineral spirits turn the oil paint into a fluid medium. They are useful during the painting process as well as to clean the brushes or the palette. Experienced artists mix solvent with oil to create a substance that does not reduce the viscosity of the paint. Caution must be exercised, however, with the proportions of the mixture (approximately one part oil to four parts solvent) so the excess oil does not ruin the finish of the work.

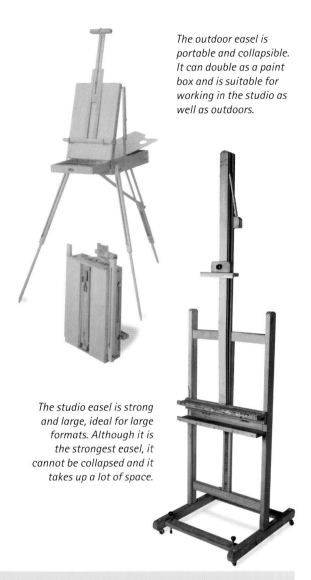

The outdoor easel is portable and collapsible. It can double as a paint box and is suitable for working in the studio as well as outdoors.

The studio easel is strong and large, ideal for large formats. Although it is the strongest easel, it cannot be collapsed and it takes up a lot of space.

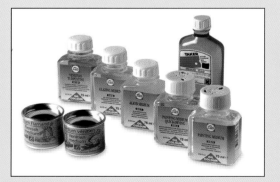

VARNISHES AND MEDIUMS

The artist can use mediums and varnishes to change the consistency of the paint, the drying time for touch-ups, and to add glossiness. Mediums are substances that are added to the solvent or the paint to alter some of its characteristics. The most commonly used are the secatives, which must be used with extreme care to avoid cracks in the paint. Among the different types of varnishes, there are two that should be singled out: one is used for touching up (for restoring glossiness to matte areas), and the other is a protective varnish, which is applied over the surface when the paint is dry. As a rule, it takes a year to guarantee a perfect and complete drying of the project, although this depends on the atmospheric conditions and the thickness of the paint. There are glossy and matte varnishes available, in bottle or spray form. However, few artists use them because most of them prefer the painting to show the natural shine of the oil paint.

Drawing Materials, Palette Knives, and Rags

The drawing materials that must always be kept at hand are charcoal sticks, erasers, and soft lead pencils. Charcoal sticks are used to sketch the composition on the canvas, and the pencils are used for sketching on paper. It is always better if charcoal sticks are thick. A small piece of the charcoal stick can be used for details or fine lines. Palette knives are essential for cleaning the palette (long and flexible "palette knives"). Trowel palette knives, for example, are very useful for scraping off the paint or for applying it to the canvas as an impasto. Working with oils can turn into quite a messy job, so it is essential to always have papers around (newspaper scraps) and old rags to clean your hands or clothing (when they get stained), as well as to correct and remove paint from the brushes, and to maintain cleanliness in general.

Scraps of newspaper are very useful for removing the excess paint from the brushes, as well as for cleaning the palette.

Palette knives come in many shapes. The flexible and long ones are the best for cleaning the palette; the stiff and triangular ones (in the shape of a trowel) are the best for applying color. The latter type can also serve for general purposes.

To maintain general cleanliness, it is always good to have rags and absorbent kitchen towels at hand.

THE USE OF MEDIUMS

Manufacturers continue to develop new additives or mediums for modifying the consistency, drying time, glossiness, consistency of the paste, or the texture of the oils. It is not a good idea to use any of them until the artist becomes more experienced working with oils. Time and practice are essential so that the artist will be able to know when to change the normal quality of the paint by adding some of these substances.

BRUSH CLEANERS

There are some implements specifically designed to keep the brushes clean, which are known as brush holders. They consist of a double-bottomed container with a holder on its upper part. The brushes are set tight in the holder so that they are suspended vertically, with the bristles submerged in the mineral spirits. The excess paint dissolves, and comes off the hair, and falls inside the first removable bottom. This first bottom has holes, so it can be removed and cleaned without wasting the mineral spirits, which remain relatively clean and can be reused.

Cleaning and Maintaining the Brushes

The oil painting brushes should be cleaned after each session. The most practical way is by removing the excess paint from the bristles with a piece of newspaper. The bristles should then be cleaned with mineral spirits to dissolve all the paint. This last operation alone is not enough to clean the bristles completely, and even if it was, they would suffer from the corrosive effects of the mineral spirits. The brush should be washed with water and soap. The ideal way is by rubbing the bristles on a large bar of soap. Once the hair has been covered with soap, the brush is rubbed against the back of the hand and rinsed with tap water. This operation will be repeated as many times as needed until the soapy water is no longer tinted with paint. After the last rinse, the bristles are reshaped and the brushes put aside in a can or jar with the bristles facing upward. If the time between sessions is not going to be very long, the brushes do not need to be cleaned but simply left submerged in water. They should not be left like this for more than one or two days. Good brushes are expensive, but if they are carefully used and maintained, they can last a very long time.

A GOOD IDEA

Sometimes, when being transported, the brushes get damaged, the bristles becoming bent or separated from having moved inside the box. When the brushes are properly arranged, this will not occur. If the brushes are not going to be carried inside the artist's box, it is a good idea to use a bamboo mat, like the one shown in the picture. It is light and it does not take up more space than the brushes themselves, and it protects the bristles.

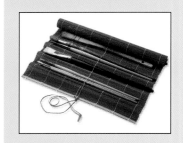

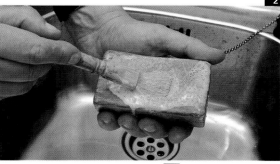

1 First, the excess paint must be removed from the bristles by wiping with a piece of paper.

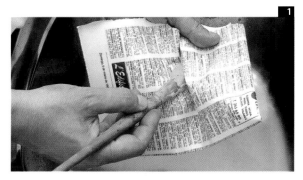

2 After rinsing the bristles with mineral spirits to dissolve the remaining thickened paint, they are scrubbed with a large bar of soap.

HOW TO CLEAN OIL PAINT STAINS

If your clothing is stained while you paint, the first thing to do is to rub the stain with a solvent to remove as much of it as possible. Immediately after that it must be rubbed with soap and rinsed until there is no paint residue or stain from the solvent.

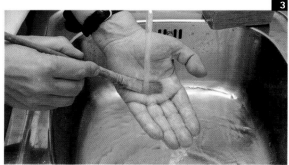

3 When the bristles have been lathered, the brush is rubbed against the palm of the hand until the soap is no longer tinted with the color of the paint.

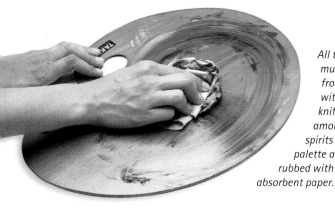

All the leftover paint must be scraped off from the mixing area with the palette knife. Next, a small amount of mineral spirits is poured on the palette and the surface is rubbed with a piece of absorbent paper.

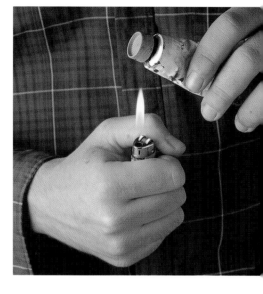

If the paint has dried out around the lid, simply heat it up a little to open the tube.

Cleaning the Palette

It is very unpleasant and uncomfortable to mix colors over leftover paint that has hardened on the palette because it was not cleaned after it was used. The palette should be cleaned after each painting session. First, the paint deposits are scraped off with a palette knife, then, after pouring a small amount of mineral spirits on the wood, the palette is rubbed with a piece of absorbent paper. As mentioned on previous pages, if you prefer, the areas with the paint can be left, cleaning only the central portion reserved for mixing colors. In this case, the procedure will be the same.

Caring for the Paint

Taking care of the paints does not require special care. The only preventive measure is to close the tubes properly after each session. When the paint has dried out at the opening, it is always possible to pierce through the hard layer with a little stick to free up the paint that is in good condition. When this is impossible because the paint has hardened, a last resource is to open the tube from the bottom and to remove as much usable paint as possible. Finally, when the paint has hardened around the lid and it is stuck, the threads of the lid can be warmed up with the flame of a lighter, after which the tube will open easily.

HOW TO CLEAN THE PALETTE KNIFE
The palette knife must also be cleaned because if the paint on it dries, it will not be usable for painting or for any other purpose. It can be cleaned with another palette knife, or with a different knife. All the leftover paint is scraped off and the palette knife is rubbed cleaned with a rag.

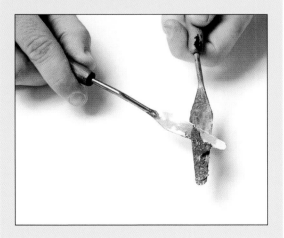

Your hands should be washed with soap and water, without abusing the solvent, because it will cause them to dry and crack. Today, there are special creams for painters that wash the difficult stains more efficiently than soap. A homemade cleaning alternative to these creams is to use liquid hand soap mixed with very fine sawdust.

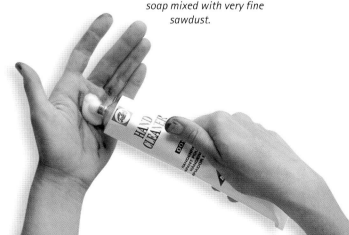

"Cleaning" the Canvas

Oil paint is an extraordinarily versatile medium that allows many more possibilities for touching up and correcting than any other artistic medium. If the paint is still wet, the entire work can be literally erased by first scraping it with a palette knife and then rubbing a brush soaked in mineral spirits on the canvas to dissolve the color. Then a dry cloth is used to rub it again until no fresh paint is left on the canvas, however, it will continue to be stained, so to finish cleaning, the canvas should be rubbed with another clean rag soaked with solvent. Artists often reuse old paintings that did not turn out so well to paint over. If the surface has too many wrinkles and bumps of dry paint, they must be sanded down with sandpaper. To get an even background, the surface can be repainted with a layer of paint that does not contain too much mineral spirits.

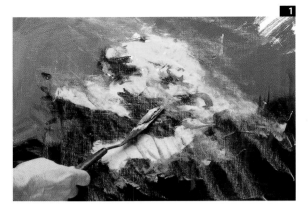

1 If a surface where the paint is still wet has to be cleaned, the paste must be scraped off with a palette knife.

2 The paint deposited inside the weft of the canvas is dissolved by rubbing the fabric with a brush soaked with mineral spirits.

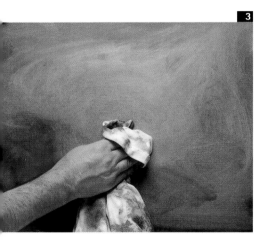

3 The paint dissolved on the canvas is wiped off with a rag.

4 To finish cleaning the fabric, it is rubbed with a clean cloth saturated with solvent.

FRAMING

Framing the paintings always depends on the taste of the artist and the potential buyer. The frame can either be a strip of varnished or painted wood, or a luxuriously ornate frame. The style of the artist is a determining factor. Many contemporary artists do not frame their paintings, but instead use heavy canvas to give the painting a better presence. If the surface of the painting is cardboard, framing is essential, either covered with a piece of glass, like drawings and watercolors, or using a conventional oil painting frame.

The Pleasures of Paint

There are many ways of painting with oils. However, there are certain limitations and conditioning factors that must be kept in mind to achieve the maximum performance from the medium, without losing its natural characteristics. The following pages are a guide for the basic procedures.

Painting should, above all else, be a pleasurable undertaking. For an artist who works with oils there is nothing that can be compared to the feelings provided by this medium—handling the paint, mixing it on the palette or on the canvas, spreading the paste, creating textures with the palette knife by mixing tones while spreading them on the canvas, applying brushstrokes, transforming them, and covering them with new paint, and so on; for the true artist, the physical aspects of handling the paint and the tools are as important as the finished work. In the following pages we will see what the process of the artist is for creating his or her colors and works of art, to give shape to his or her observations of nature or the dictates of the imagination. Practice is always the best guide, and practicing with oil paintings is a very pleasurable experience. It is also demanding; the colors that appear vibrant one minute turn muddy the next without us even noticing it. Because oils are extremely fluid and malleable, which can be an advantage or a disadvantage, a distraction during mixing will invariably produce a color that is dirty or not defined, and neither the brush nor the palette knife will create the desired result. All these drawbacks are logical and natural, and create the great interest of this medium. By following our explanations, the reader will understand the mechanics and the logic that govern the handling of paint and how we can get the most from it.

◆

It is the manual and physical process of painting that is as important for the true artist as the finished work.

◆

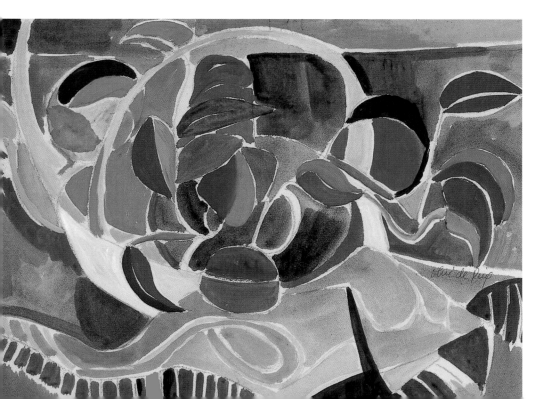

Esther Olivé, Painting. Private Collection. Oil painting is by far the most colorful medium, but it also allows us to create perfectly coherent work with very few tones.

Mixing Colors

If we review the basic facts of mixing colors, we will realize that in theory all colors can be created by mixing only three of them, which are called the primary colors: yellow, blue, and red. Mixing them in pairs will produce the secondary colors: orange, green, and violet. Mixing these six colors multiply the number of tones until we reach the complete color range. This is the basis of color mixing, and even though the ones we use on our palettes may be much more extensive, this logic is always constant, as is the fact that mixing blue and orange, yellow and violet, and green and red produce grayish colors. The pairs that we just mentioned are called complementary colors. Any pair of colors similar to the latter will produce a result that is close to the one indicated.

Mixing the primary colors red and yellow results in a secondary color orange.

Mixing the primary colors yellow and blue will give the secondary color green.

Mixing the primary colors red and blue will result in the secondary color violet.

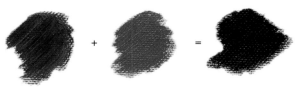

Mixing red (primary) and green (secondary) will produce a greenish brown. Red and green are complementary colors.

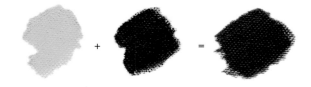

Mixing blue (primary) and orange (secondary) will result in bluish gray. Blue and orange red are complementary to each other.

Gradation by diluting the paint.

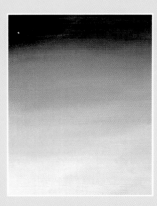

Gradation by adding white.

BLENDING AND GRADATIONS

Oil paints mix with perfect homogeneity. This trait makes them suitable for blending and for creating gradations from light to dark and vice versa. But these effects can also be achieved by adding more or less solvent to the paint, as if we were working with watercolors. The solvent reduces the intensity of the color and makes it transparent; therefore, when spreading it on the white canvas it appears lighter than if the same color were denser.

Mixing yellow (primary) and violet (secondary) results in a very dark gray, which has a slight tendency toward green. Yellow and violet are complementary to each other.

How to Lighten and Darken Colors

Common sense dictates that to make a color lighter white must be added, and to make it darker, we should add black. The first point is always correct, but the second, most of the time. There are important exceptions, such as yellow and similar colors, which, mixed with black produce a dirty green or a grayish tone. The truth is that yellow cannot be darkened unless we consider orange a dark yellow, in which case it is clear that yellow is not "darkened" with black but with red. In general, white and black decrease the color saturation, and take away vitality; therefore, they must not be abused, especially the black.

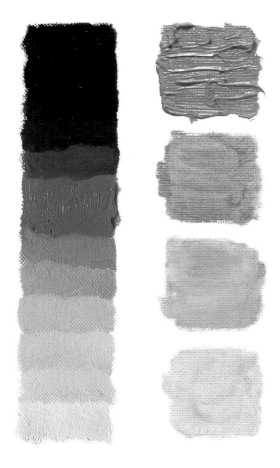

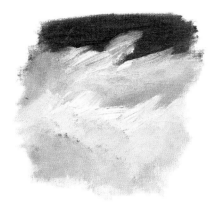

Blue is not affected by making it lighter with white, and darker with black. In both cases the result is a lighter and darker blue, respectively.

Red turns pink when made lighter with white, and brown when it is darkened.

Orange can be lightened by diluting it repeatedly, which makes it progressively more transparent, and also lighter without losing too much of the tonal intensity.

THE CHROMATIC RANGE
We know by intuition that colors are mutually related, so some of them are more harmonious together than others. Yellow, for example, matches with certain greens, and with orange. Red can easily be paired with carmine and pink. Sienna and brown also form a pleasing color combination. We could continue forming color families; arranging interesting color combinations is an educational exercise that can be done with paint or by gluing cutouts onto a piece of paper. But all those potential variations can be summarized in three large color families: warm, cool, and neutral, or gray colors.

Yellow turns lighter when mixed with white, but tends toward green when mixed with black.

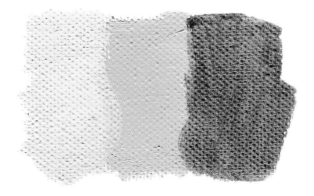

The Subject of Grays

In the previous pages we have seen that, within the logic of color, there are certain mixtures that result in gray. It is important to remember at all times what those mixtures are, so we do not fall prey to lifeless tones as a result of mixing mistakes. When the errors produce a gray tone, adding white will serve no purpose, because it will weaken the color even more. Grays are perfectly valid (and necessary) if they are used purposely, but if they are the result of an accident, they show a lack of knowledge of the laws of color. The lesson that we wish to convey is that indiscriminate mixtures of colors must be avoided. Also, we must remember which colors are the ones that can be darkened and lightened with black and white and which ones should be mixed as little as possible.

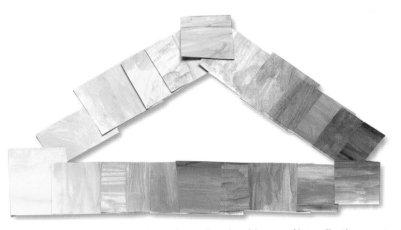

In this triangular distribution of the entire chromatic scale, the arrows indicate the colors that, when mixed with one another, result in gray. As you can see, they are opposite colors, complementary colors.

The grays that result from mixing just white and black are cold, neutral, and clean.

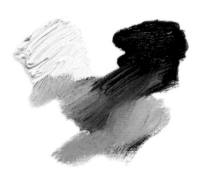

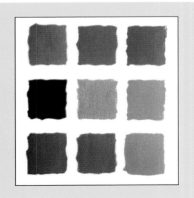

A complete chromatic scale can be made only with grays. Naturally, they must be tinted grays, which have a tendency toward yellow, pink, green, blue, etc. These colors, used with caution, constitute an essential factor in creating harmony in a painting.

TINTED GRAYS

Grays produced by mixing two complementary colors, also called neutral, are "impure" colors, which show a tendency toward a full color without reaching that status. Included in this category are the browns and greenish grays, reddish browns, green sienna, dark greenish blues, etc. Just the names used to define them show that these tones are not as pure as the primary or secondary colors. These neutrals may have a warm or cold tendency that can be better appreciated when they are lightened with a little bit of white. The muted aspect of these colors offers a lot of chromatic possibilities within a harmonious work.

Monochromatic Painting

Monochromatic painting is working with a single color lightened with white or darkened with black, in other words, painting with grays. The color can be any of those that are not too affected by mixing with black or white. Logic dictates that this color be dark; normally monochromatic painting is done in blues or browns. Painting monochromatic schemes is an excellent exercise because it allows the artist to study and practice tonal gradation and blend without thinking about color arrangement. It all consists of abstracting color from real themes and paying attention only to light and dark values, representing them with mixtures of the chosen color and black and white.

Any subject is good for practicing monochromatic painting, but the themes that have tonal contrasts are easier that those with strong color contrasts.

This monochromatic painting done from the previous study has been created with raw umber, darkened with black and lightened with white.

GRAYS ARE IMPORTANT

Chromatic harmony needs grays as much as it needs the brightest color. Naturally, we are referring to classic harmony, the one that seeks a serenity of color contrast and not an explosion of colors. In classic harmony, like the work by Cézanne shown here, grays play a role as medium tones, as contrast buffers. The illustrations show the reconstruction of the painting with colored paper cutouts.

Paul Cézanne, Mountains in Provence. National Museum and Art Gallery of Wales, Cardiff, Great Britain.

This is a schematic reconstruction of Cézanne's landscape done with colored cutouts. We can appreciate the importance of grays in the value work of the landscape's colors.

Shown here are all the colored paper cutouts used in the previous scheme. The grays outnumber by far the variety of tones of any other color.

The Brushstroke

In oil painting, the presence of brushstrokes, aside from being inevitable, may serve to suggest the shape of the objects in addition to their color. Because oil paint is thick, the brushstrokes have a stronger influence and presence than in any other medium. The artist must take advantage of this circumstance to define the subject matter with brushstrokes, drawing with them not only the contour but the entire shape. This is how Impressionist painters worked and the reason for the freshness and spontaneity of their work, which does not mean that the paintings where the brushstrokes have been concealed have no value. On the contrary—working with paint whose shape coincides with the brushstrokes gives the work an incomparable vitality.

The power and precision of these brushstrokes define the shape of the entire flower. Two yellows were involved here, tinted with a little bit of white.

The color of the brushstrokes that define this flower have been created by superimposing a light brushstroke over a dark one of thick and wet color.

THE PERFECT "FINISH"

If we look around in a museum that has classical paintings, we will observe an interesting fact. Old paintings, and still lifes in particular, have a smooth surface without any visible brushstrokes, especially if we compare them with modern paintings. This smoothness is due in part to the successive layers of varnish that the surface has been treated with, but mainly it is due to the requests of the clients of the time. The art collector of Renaissance and Baroque paintings demanded a perfect finish, without any brush marks, where all the colors responded to a uniform continuity; therefore, the artist was forced to erase any trace of his work.

Jacques Linard, The Five Senses and the Four Elements. *Louvre Museum, Paris, France.*

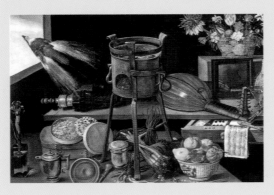

These flowers have been painted with different types of colors and strokes, which, due to the variety of their shapes, create a very interesting composition in terms of color and form.

The subject matter in this work suggested a treatment based on brushstrokes. Notice how the artist, Esther Olivé, has taken full advantage of this.

CALLIGRAPHY

In many cases, the clear presence of the brushstroke is due to the artist's calligraphic idiosyncrasy. Its shape has to be related to a "letter," the manual calligraphy of the painter. These brushstrokes can be long or short, made with dots or commas, thick or thin, crisscrossed or parallel, etc. All this variety is dictated, first, by the characteristics of the subject matter, but also (and to a great extent) by the capable and inventive mind of the artist for creating a rich and varied canvas with brushstrokes.

The background is also treated with brushstrokes, which do not completely cover the canvas with a single tone. These gaps suggest the space that opens up behind the vase.

Impasto

Impasto means applying thick paint without diluting it with mineral spirits. The impasto created with brushstrokes produces a characteristic texture, with ridges and irregularities that can be more or less pronounced, depending on whether the paint is applied with more or less oil (more or less "dry"). And in referring to impasto, we must also talk about palette knives, which are the tools that allow us to load and apply the most amount of pigment on the canvas. The palette knife, leaving aside its use as a cleaning tool for the palette or for scraping the canvas, is used by the artists to apply areas of thick paint, without traces of brushstrokes but with abundant texture. Even if the color is the same, its appearance varies depending on whether the paint is applied as impasto or very diluted. This is one of the most peculiar characteristics of oil painting that makes it a medium full of variants and possibilities. The areas of paint do not depend only on the paint itself but on its consistency as far as texture and thickness is concerned. Paint applied with a rich impasto offers a solid color surface, which is as interesting for its richness of color as for the subject matter.

This painting by Marta Duran is a perfect example of the impasto technique. The painting has been worked on with a palette knife and large flat bristle brushes that can be loaded with great amounts of paint.

The white of the house has been applied with a few thick brushstrokes, which make the textured surface of the background stand out. This type of brushstroke is achieved when the paint has not been diluted, but used as it comes out of the tube.

This illustration shows the initial phase of the painting. The artist works on a dark surface that has a lot of texture and is very dry, which covered a previous unsuccessful work. From the very first strokes, the energetic style can be appreciated; it is based on the application of thick paint, using hardly any solvent.

The reflection of the trees has been created with thick lines of paint using a small flat brush. A lot of paint has been used so it would not mix with the color of the background.

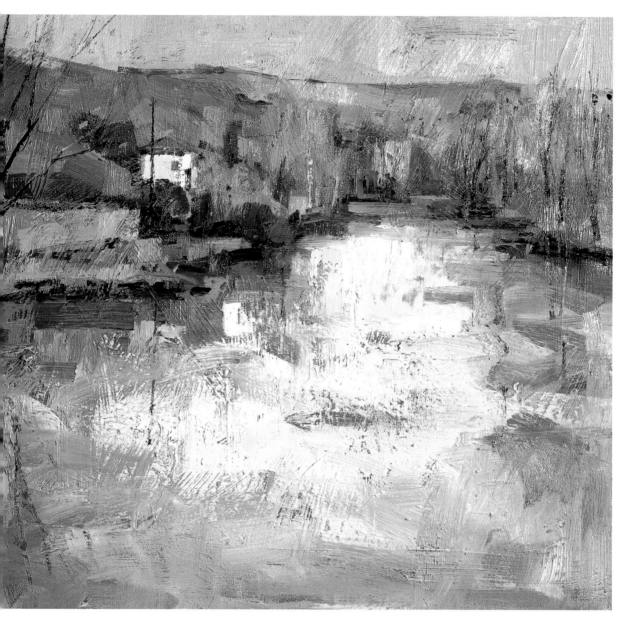

The reflections of the water have been created with the palette knife, spreading masses of thick paint in different directions and using a palette of very light complementary colors.

IMPASTOS AND COLOR BLENDING

If modeling is to be done by blending colors, that is, gradually changing tones by mixing them on the canvas, the impasto could present some problems. If all this blending is done with pure paint, the project could end up having a pasty appearance, without color energy and without plasticity. Most artists used to modeling by blending colors try not to abuse the use of too much or too little paint.

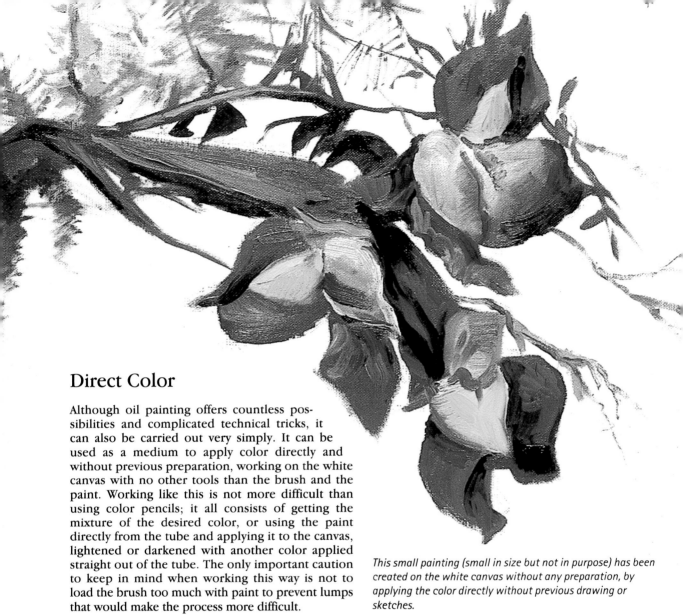

Direct Color

Although oil painting offers countless possibilities and complicated technical tricks, it can also be carried out very simply. It can be used as a medium to apply color directly and without previous preparation, working on the white canvas with no other tools than the brush and the paint. Working like this is not more difficult than using color pencils; it all consists of getting the mixture of the desired color, or using the paint directly from the tube and applying it to the canvas, lightened or darkened with another color applied straight out of the tube. The only important caution to keep in mind when working this way is not to load the brush too much with paint to prevent lumps that would make the process more difficult.

This small painting (small in size but not in purpose) has been created on the white canvas without any preparation, by applying the color directly without previous drawing or sketches.

PAPER

Some artists use paper for their sketches and small oil studies. However, paper can become stained and yellowed from absorbing the oil. The result of oil painting on paper is always matte, although a surface that is well prepared with a layer of acrylic paint or gesso can be a good remedial step and may prevent these problems.

This darker tone shows the true color of violet, which is a lot darker. When applied in pure form it is used to define the shadow created by a fold on the flower's petal.

These leaves and branches have been drawn with the tip of the brush, allowing the bristles to slide on the canvas and leave a trace of very diffused color, without any previous drawing to serve as a guide.

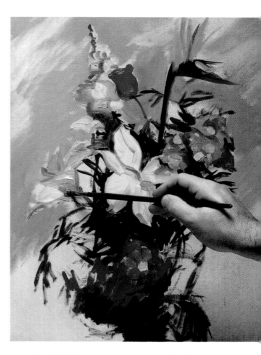

Brushstrokes play a very important role, painting with direct color, defining the shape as it goes; because of them the volume and the three-dimensionality of the objects in the composition are defined.

The yellow of the flower does not require any complicated techniques. The tone is simply the color of the paint as it comes out of the tube. The violet (its complementary color), which creates a strong and vibrant contrast, is slightly lightened with white.

The violet's lighter tones have been created by mixing a little bit of white directly on the canvas.

COLOR CONTRAST
If a light gray is surrounded by dark blue, it will appear almost white. By the same token, if carmine is surrounded by white it will appear darker than if it were surrounded by black. The more diverse the tones that form part of a painting, the more such contrasts will be created. These contrasts reach their maximum intensity when complementary colors are set against each other, like the painting studied in these pages. Yellow is surrounded in each of the flowers by its complementary, violet.

Painting with Blocks of Color

The technique of direct color application offers good results in only a handful of circumstances, only when the subject matter has bright colors and there is no need for spatial representation, in other words, when it is a simple composition with no atmospheric feeling. In most cases, it is necessary to work methodically, approaching details from an overall point of view, and not the other way around. This technique is based on painting with color blocks, and guarantees organized and balanced results in all areas of the painting. The following sequence illustrates this process.

MATERIAL
- Canvas or canvas panel
- Charcoal
- One medium-size flat brush
- Paints: ultramarine blue, ochre, emerald green, and white

1 The subject matter is a house by a lagoon. The most outstanding block of color is the one that suggests the sky and its reflection on the water. This entire block is painted with the same light blue color, dissolved with quite a bit of solvent, respecting the outline of the building that was previously drawn with charcoal.

2 The second important block is the color of the horizontal band that forms the edge of the shore. The color used here is ochre mixed with a small amount of blue lightened with white.

3 The third basic block is the one formed by the leaves of the palm tree and their reflection on the water. The technique of painting with blocks forces the artist to forget the details and the nuances while covering the canvas with paint. The most important thing is to achieve a balanced composition.

4 All the color applications and shading of the finished painting have been made possible thanks to the initial blocking work, which guarantees the correct arrangement of the piece without causing any unbalance due to excessive attention to detail.

TECHNIQUES USED

- Preliminary Drawing -
- Underpainting -
- Shading -

Oil Painting Techniques and Subjects

In the following pages various oil painting subjects are presented and explained step by step. Each technique illustrates a characteristic of this procedure through examples, and the entire section offers a wide overview of oil painting and its countless possibilities.

After reviewing the materials and the different ways of using oil paint, the moment has come for the practice. The following pages explain in detail the basic steps for working with oil paints. In this medium, as in any other medium, each artist has his or her own preferences, but the following pages present general and widely accepted methods that will help you avoid problems during the painting process. However, these general principles are of little use if they are not applied and adapted to specific subjects. It is not the same to paint a figure as a landscape; each subject matter requires some adjustments.

The following pages are organized in a way that will allow the reader to see and understand how the basic oil painting processes are adapted for different subjects and different purposes. We begin with a painting that is almost entirely monochromatic, which reduces the problem of color mixing to a minimum, and progress to full color. This way, the reader will gradually become familiarized with the different techniques required for each project based on its color, light, and the number of shapes in it. All the projects in this section can be finished in a single session. This does not mean necessarily that they will turn out well the first time around, but that is not a serious problem, because oil paints can always be corrected and retouched, whether they are wet or dry, an opportunity that all lovers of this medium appreciate and take full advantage of all the time.

The method of working with oils is very simple. It begins with the general and ends with the specific, progressing from less to more.

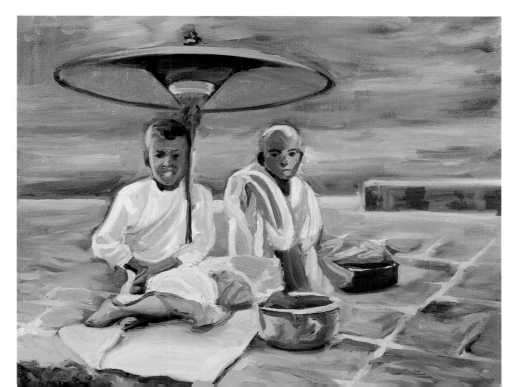

In the following pages we will cover a series of exercises that illustrate the basic oil painting techniques.

From a Sketch to a Painting

The first step for creating an oil painting is to make a preliminary drawing. This can include a few almost abstract lines, or a detailed representation of the subject. The normal approach is for the initial drawing to be a sketch, sufficiently complete to make the subsequent painting job easier, but not so defined that the lines are visible through the paint. Charcoal can be used, although some artists prefer to begin sketching directly with the paint. Charcoal is highly recommended because it is easier to correct until the artist is pleased with the basic initial drawing. This drawing is followed by underpainting, followed by the adjustment of the colors and the application of details. Below, the basic stages for creating an oil painting are explained and illustrated.

MATERIALS
- Canvas or canvas panel
- Charcoal
- Large brush
- Medium-size flat brushes

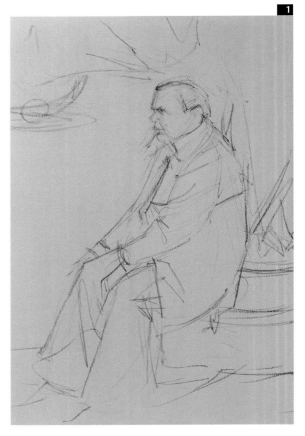

1 This is the sketch, a charcoal drawing that is not highly detailed. The lines mark the outlines between the areas of color. The goal is to create a basic scheme of the subject, which will help arrange the areas of color. Once the drawing is finished, the charcoal lines must be wiped with a cloth so they do not stain the colors.

ERASING THE CHARCOAL LINE
The charcoal lines must be erased with a clean cloth so they do not ruin the colors. In this case, erasing them does not mean eliminating them completely. After wiping them with the rag, there is always a trace of the lines left, a more than sufficient guideline to begin painting.

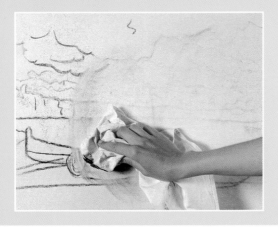

THE COLOR OF THE BACKGROUND
The painting in this example is done on a blue background. This background is a simple layer of color painted on the canvas with the purpose of improving the overall tone. Some artists prefer to work on a colored base to avoid the raw white of the canvas.

TECHNIQUES USED
- ◆ Preliminary drawing ◆
- ◆ Diluted paint ◆
- ◆ Thick paint ◆

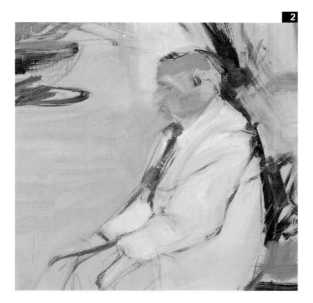

2 The second phase shows the general arrangement. At this point the paint used should be mixed with a lot of solvent so the brush can slide easily over the canvas. The normal procedure is to use thick brushes that cover a lot of surface with few brushstrokes. Notice how at this stage the brushstrokes are much more visible than the details of the figure. The entire canvas is painted to create a general view of the composition.

3 Now the brushstrokes do not limit themselves to covering the canvas; instead, they are applied according to the subject matter. In the figure for example, the distribution of the brushstrokes on the pants represent the wrinkles of the fabric and the shape of the composition.

PAINTING AND DRAWING

During the painting process, the paint itself defines the drawing, creating details, modifying contours, and making the shapes stand out. Color, therefore, also draws, and does it by using the initial, simplified sketch of the theme.

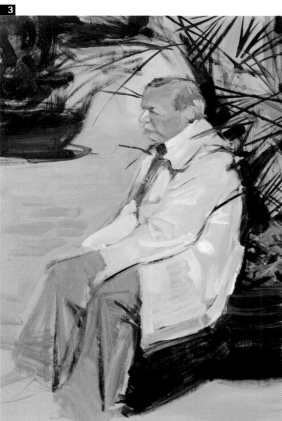

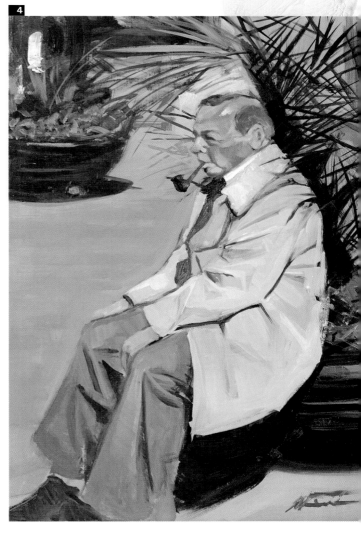

4 The previous phase is developed until the form has been perfectly defined and the color is confined within the outlines of the drawing. It is in this last stage that the artist must work with more paste, gathering color to model the volume and to give the surfaces some proportion.

Modeling

Modeling is giving volume to the painted shape, or, in other words, representing the forms in three dimensions on a two-dimensional surface, that of the flat canvas. Therefore, modeling constitutes one of the basic techniques of every oil painting project. For practical purposes, modeling means to darken or lighten the color depending on the effects of light and shadow. Oil paints, because of their ability to mix, make modeling easier than any other medium. To better illustrate this point, the following exercise explains painting using a sculpture as a model. A white statue is lighted in such a way that different shadows can be appreciated. It consists of painting only with black and white (plus the blue of the background). This exercise, in addition to showing how to do a chiaroscuro, also offers a very detailed look at the characteristic process of any oil painting.

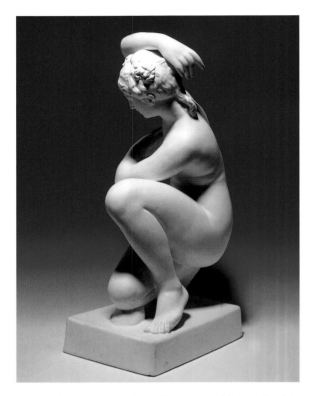

This plaster statue is similar to the ones used in art schools to learn how to draw and paint. Before paint is used, the student must learn how to model the figure, blend tones, and create the feeling of volume.

1 In this type of composition, a preliminary detailed drawing is essential. Here, the shape of the statue must be perfectly defined before the painting begins. Charcoal can be corrected as much as needed, and it is important to continue working with the drawing until it fits proportionately within the format. When the drawing is finished, the excess charcoal is removed with a rag.

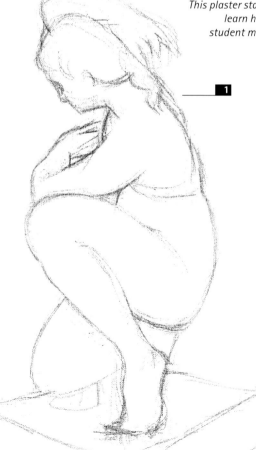

1

MATERIALS
- Canvas or canvas panel
- Charcoal
- One medium-size flat brush and one fine round brush
- Colors: titanium white, ivory black, and ultramarine blue

TECHNIQUES USED
- ◆ Preliminary drawing ◆
- ◆ Underpainting ◆
- ◆ Modeling with grays ◆

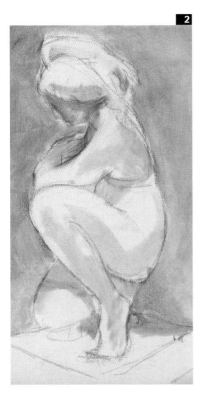

2 This is the first layer of color painted over the drawing, which has been properly concealed. Here, very diluted black and blue are used so much that the effect looks more like a watercolor than an oil painting. It should be like that at the beginning of any process.

3 The previous color layer serves as the first guide through the light and dark areas, and also for identifying the more shaded areas. From this point of reference, black and white should be mixed to get the grays that shape the figure. Light and dark brushstrokes are applied to the canvas, and are blended by rubbing with the brush.

4 The background is darkened before continuing with the modeling. The dark background is a good reference for contrast and allows the artist to see clearly which areas must be shaded and with what intensity.

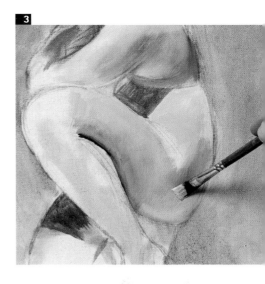

LIGHTENING AND DARKENING
Oil paints can be reworked more than other mediums; others require you to decide which color to use first, because it is not possible to lighten the tones as you progress. When painting with oils you can go from light to dark or vice versa, but it is a good idea not to darken the canvas too much at first, or all the colors will have to be lightened.

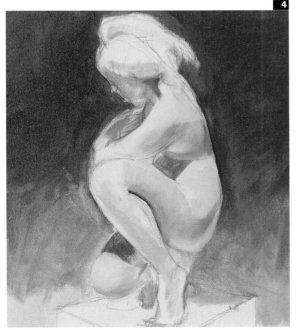

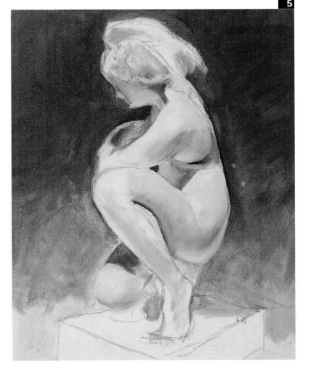

5 From this point on, it is a matter of darkening the shading little by little, restoring the light areas with applications of white paint. Black should not be abused because it is always easier to darken than to lighten; therefore, work must be done with patience, beginning with the lighter tones and progressing toward the dark ones.

Modeling Defines the Volume

Modeling defines the volume and also whatever is in the foreground of the composition; it gives dimension to the space. All of this happens because of light, which produces shadows on the volumes. Light allows modeling and creating the feeling that some shapes are farther away than others and that they have some solidity, that they occupy space. These pictures show how the modeling process continues once the general areas of light and shadow have been established. Now it is simply a matter of adjusting the mixtures of black and white.

◆

Modeling defines the volume and creates the feeling of space thanks to the combination of light and shadow.

◆

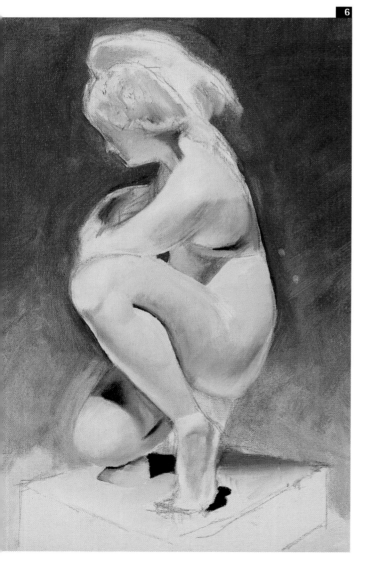

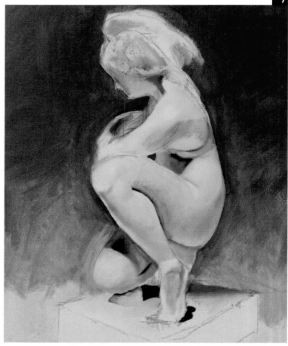

6 Now, thicker paint is used. It should not be too lumpy, but sufficiently dense to cover the canvas properly and to be workable, mixing it on the canvas if needed, blending the tones.

7 While working on the form, the surfaces become more evenly distributed and the transition from light to shadow becomes more logical and natural. Here, the modeling work consists of making light tones blend with the dark ones in a progressive way and without sudden changes of tone, with the exception of the areas darkened by projected shadows.

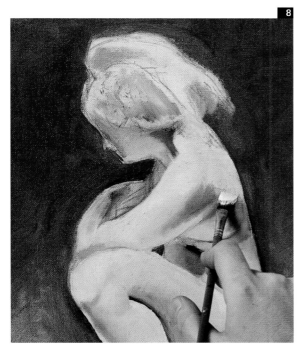

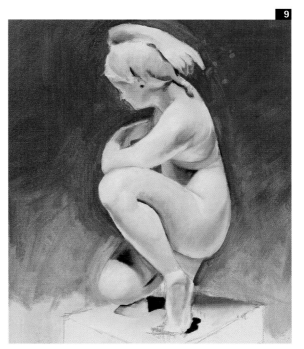

8 Here is the proof that oil paints can be corrected very easily. With a single brushstroke of thick white paint, the top part of the shoulder is painted over, covering the previous shadows and repainting that area as if you were starting over.

9 Gradually, all the areas of the figure begin to adopt a unified, coherent look. The volume becomes increasingly credible and the statue begins to occupy a real space in the composition. All of this is due to the blending of white and black, which gives volume to the forms.

10 Here, the bottom part of the legs and the foot have been defined. In reality it is just the beginning of the modeling in an area that still showed the paint from the first application.

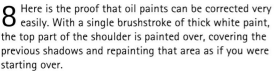

THICK PAINT: FROM LESS TO MORE
The density and pasty consistency of oils become very helpful when one tone must cover another. The color underneath does not show through and it is totally eliminated, but it must not be abused because if the artist works with a lot of paint for a long time, the color can become muddy. The intensity of the color should be increased gradually and the work should be approached as much as possible with paint that is not too thick.

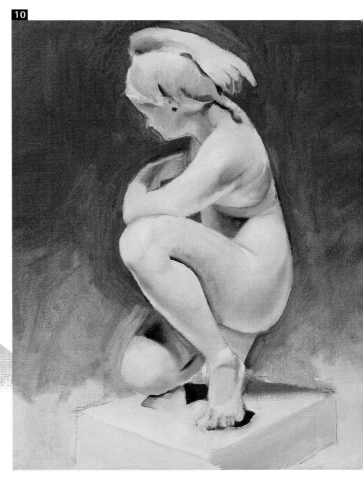

When to Finish

One of the dilemmas of every artist is how to know when the painting is finished. It is a question with a difficult answer because the end always depends on the effect that the artist wishes to achieve. You can say that a painting is finished, however, when you arrive at a point where all the areas show a good amount of elaboration, and where none of the areas seem incomplete in comparison with the others. In this exercise, the work will be considered finished when there is continuity in all the contours of the statue.

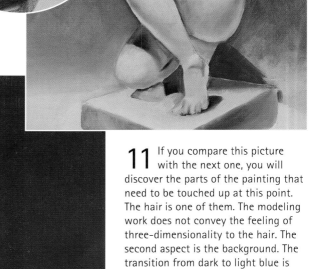

11 If you compare this picture with the next one, you will discover the parts of the painting that need to be touched up at this point. The hair is one of them. The modeling work does not convey the feeling of three-dimensionality to the hair. The second aspect is the background. The transition from dark to light blue is not sufficiently soft and continuous.

GRADATIONS WITH PAINT
A color gradation with oil paint can be achieved by adding solvent to it, but also, as shown in this picture, by applying a layer of white paint.

12 The hair of the statue has just been shaped by adding shadows that suggest the curls. The background is now more in tune with the figure because the brushstrokes have disappeared and the transition from dark blue to white is soft and gradual. The effect is that which was desired: volume, space, and a representation of three-dimensionality.

Modeling with Color

Modeling can also be created with color. In fact, every artist models with color every time he or she paints, with the intention of attaining the same goal as in the previous exercise, a good spatial representation. The best results in modeling with color are achieved when a reduced tonal range is used. Select a palette of colors that are similar to each other and that lend themselves to modeling, such as black and white, by going from light to dark naturally. This would not be possible if the colors used clashed considerably with one another. In such case, it would be difficult to create a smooth transition between them or to avoid causing unpleasant effects. Let's see what the modeling technique is, beginning with a subject that is dominated by earth tones made up of sienna and dark browns, to which light and vibrant colors are added as a needed contrast.

◆

The best modeling results with color are achieved when a reduced range of tones is used.

◆

The color of this still life can be reproduced with a very reduced range of colors—a warm component including sienna, ochre, and earth tones, with bright red and white as the basic contrast tones.

MATERIALS

- Canvas or canvas panel
- Charcoal
- Medium-size fine round brush
- Reduced range of colors

1 The preliminary drawing for this composition is very simple because it has basic outlines and the contours do not need to be perfect. A drawing with charcoal without complications is all that is needed. Once the drawing is finished it must be "erased" with a rag to eliminate the excess charcoal.

1
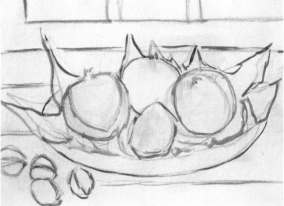

2

THE RANGE OF COLORS
The palette used for creating this painting is composed of the following colors: titanium white, cadmium medium yellow, orange cadmium yellow, cadmium red, burnt sienna, permanent green, and burnt umber.

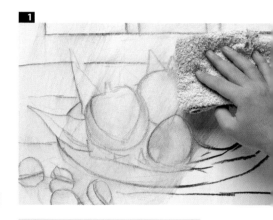

TECHNIQUES USED
◆ Preliminary drawing ◆
◆ Underpainting ◆
◆ Modeling with color ◆

2 After the charcoal lines have been erased with a rag, the overall drawing lines are retraced using sienna diluted with mineral spirits. This procedure must be done with a round, fine brush.

Shades of Similar Tones

As we saw in the previous exercise about painting with black and white, the secret of modeling resides in correctly balancing the intensity of light and dark within the same tonal range. In the previous exercise the general tone was gray. In this painting it is sienna, which produces an earthy orange tone, very warm for the entire composition. The problem that must be solved in this case is the volume of the pomegranate, modeled with lighter and darker tones (even more reddish) than the dominant color.

The overall coloring of the still life is sienna, which gives the entire composition a very warm tone.

REDDISH MIXTURES

Red is an important color in this project. Thanks to it, the tone of the pomegranates loses a little bit of its earthy color and becomes more vibrant. Obviously, this color does not take part in this composition in pure form, but mixed with sienna and yellow (and, eventually lightened with white). This way, it is integrated naturally with the dominant range of colors, which contributes to the modeling of the subject.

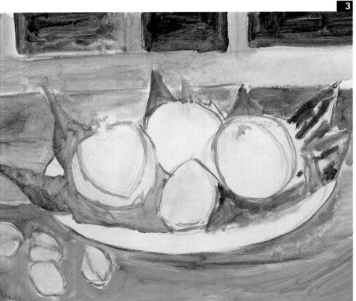

3 The initial underpainting follows the basic lines of the drawing. The colors are almost monochromatic, composed of a mixture of sienna and orange, in which only the green of some of the leaves and the dark areas of the window stand out in contrast.

4 Using a mixture of sienna, white, and yellow, we begin painting the pomegranates. This tone corresponds to their lighter areas and will serve as the base color for the subsequent modeling of the fruit, which is done in red.

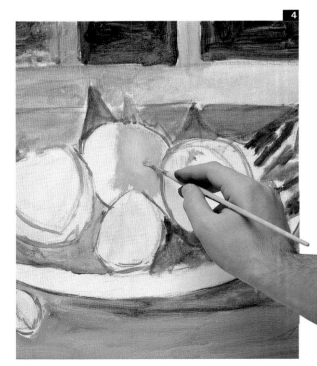

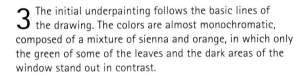

OVERUSING WHITE

As already explained in the section devoted to gray, abusing black and white ruins the color. To achieve the reddish and orange tones of this still life, sienna must be combined with the rest of the colors. White will be used only when it is absolutely necessary.

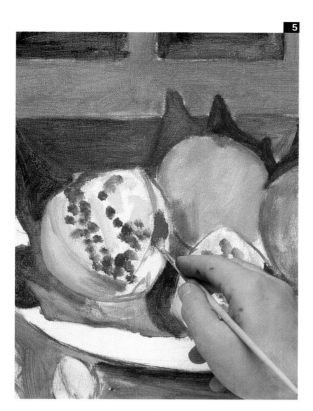

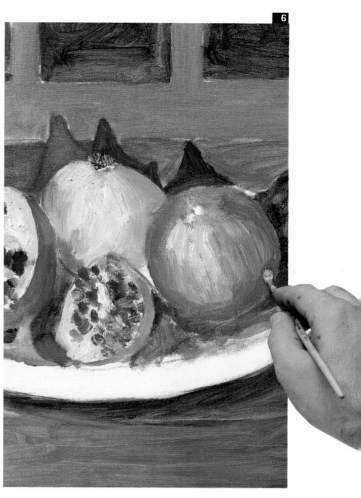

5 At this point, the still life is completely covered with color. The pomegranates have been modeled with different shades of red. Now the small seeds have to be painted with dabs of the same color. The brushstrokes (fine round) are sufficient to suggest these dots.

6 The shape of the pomegranates is touched up with rounded brushstrokes of a bright red color, to create the round shape of the fruit. Working in this manner, color and shape are created simultaneously.

7 The painting has received a lot of attention. The dominant reddish color does not prevent the important contrasts from playing a role; the green of the leaves and the light areas that surround the seeds are the most important. They are necessary to give vitality to the painting.

Finishing

Finishing in this case consists of highlighting the relief of the fruit as much as possible, without getting caught up in details. Excessive attention to details will ruin the composition and the clarity of the volumes. One way of making the composition stand out is to model the color of the plate so the profile of the leaves stands out with the greatest possible power and clarity. As has been said before, the finishing depends quite a bit on the intuition, of that sixth sense, which is developed with practice, and which tells us that no more work is needed, that the project can be considered complete.

THE COLOR OF THE TABLE
The tone of the table is a key element in this work. Its color should not be too dark, because the contrast with the leaves and the fruit would be excessive and they would appear like cutouts placed on a strange background. It should not be too light either, because then the tone would get lost in the light areas of the pomegranates. The correct tone is the one that highlights the contrasts without isolating the shapes of the still life.

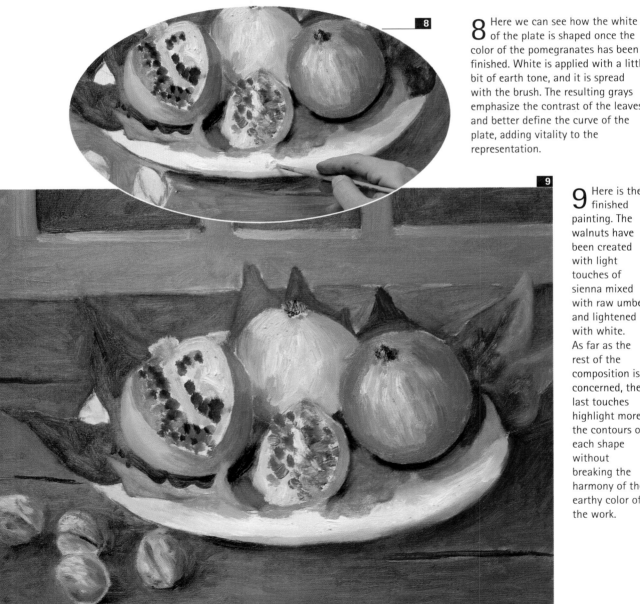

8

8 Here we can see how the white of the plate is shaped once the color of the pomegranates has been finished. White is applied with a little bit of earth tone, and it is spread with the brush. The resulting grays emphasize the contrast of the leaves and better define the curve of the plate, adding vitality to the representation.

9

9 Here is the finished painting. The walnuts have been created with light touches of sienna mixed with raw umber and lightened with white. As far as the rest of the composition is concerned, the last touches highlight more the contours of each shape without breaking the harmony of the earthy color of the work.

Painting with All the Colors

When working on subjects that require the use of the entire color palette or of the most contrasting colors of the range, modeling becomes secondary. Then the shapes cannot be defined by modeling, but with color contrasts. The stronger the contrasts, the fewer gradations of color needed, because pure colors cease to be so when they are mixed with white or black. The subject that will be analyzed below is based mainly on color contrast, but to carry it out successfully, the artist must be proficient with the modeling technique, which is used here to give volume to the birds' bodies.

MATERIALS
- Canvas or canvas panel
- Charcoal
- One fine round brush and two medium-size flat ones
- Colors: vermilion, burnt sienna, lemon yellow, yellow ochre, emerald green, green ochre, burnt sienna, burnt umber, white, and black.

It would be hard to find a more colorful subject than this pair of parrots perching on a branch. The body's red and blue, and the green of the wings, are pure, saturated colors, which must be applied directly, without too much shading. Shading should never degrade the color.

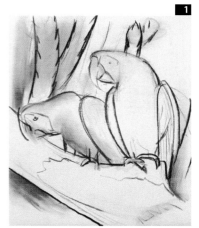

1 In the preliminary charcoal drawing, you can spend some time defining the shadows. But that is only the preparation, the "warmup" before painting begins, because those shadows are apt to disappear. What is important is to create a good composition with these two birds.

2 When the drawing has been completed, the lines are lightened with a rag, so they do not soil the color. Since we have worked the lines and shadows quite a bit, the traces of the drawing that remain after erasing are more than enough to guide the painting.

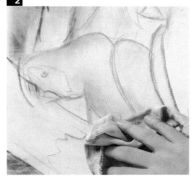

TECHNIQUES USED

♦ Preliminary drawing ♦
♦ Underpainting ♦
♦ Modeling with color ♦
♦ Color contrasts ♦

3 Many artists do this before they begin painting: go over the lines with a neutral color to solidify the preliminary drawing and to intensify the main lines. In this case, we will use burnt sienna very diluted with mineral spirits, so the brush will slide smoothly.

Painting with Pure Color

When working with very bright colors, it is better to apply them from the beginning without trying to create them from less colorful tones (as we did in the exercise on modeling with grays). Working this way, we can assess the color relationships from the beginning, making changes as needed. Therefore, when you begin underpainting with color, you must use the pure tones of the composition, although properly diluted with solvent, so the canvas is not loaded with paint from the beginning.

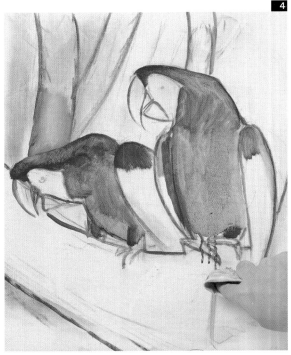

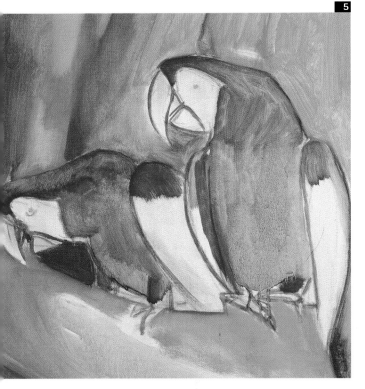

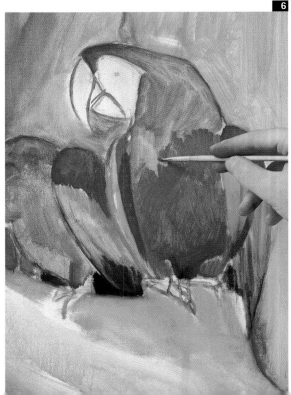

4 The first step is to paint the bodies of the birds with vermilion. It is normal for mishaps to occur during this phase, like the one shown in the painting where the excess of solvent makes the paint drip and leaves marks on the canvas. The solution is to clean those streaks with a rag. The marks that persist regardless of the cleaning will be covered with the subsequent applications of paint.

5 The initial painting should be applied to the entire canvas, without paying much attention at the moment to whether the colors conform exactly to the shapes. The main thing is to achieve an overall effect, a general view that will allow us to adjust all the factors of the painting.

6 Vermilion red is applied without blending or modeling, with the exception of the area of the legs that is in shadow and needs to be darkened to prevent the bird from looking completely flat. This dark tone is created by mixing vermilion and burnt umber.

THE REDS

There are many different kinds of reds and it is worth using several of them when we wish to keep the color clean, while at the same time creating different shades and intensities. Here, vermilion is used (light and bright red) and cadmium red (deep red).

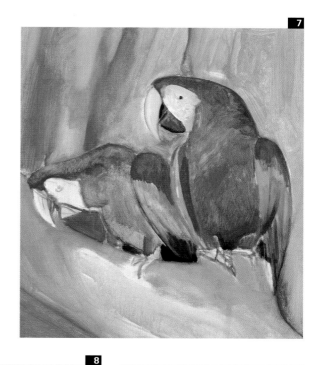

7 It is clear in this case that pure colors (the red of the plumage, and the blues and yellows of the wings) are hardly modeled, while the background, with a grayer tendency, can be lightened and darkened with white and black, in addition to green, an essential color for creating the proper shade.

8 The red has very little shading, and, above all, no darkening by mixing it with blue. Mixtures of this type would muddy the tone and would ruin the painting. But it is not a flat red, since it is modified by lighter and darker tones thanks to the intervention of cadmium red and burnt umber.

MIXING WITH REDS

The samples at the bottom of this page show the tones that are used in the composition of the reds of the plumage. The column with the three colors corresponds to the cadmium red (top), vermilion (center), and raw umber (bottom). The mark on the side corresponds to the vermilion lightened with white, a pink that constitutes the lightest tone of the ones that can be found in the plumage.

Simplifying the Details

When very intense tones are used, the details tend to get in the way because they introduce shades and contrasts that weaken the strength of the color. In the last phase of this exercise the challenge was to consolidate and blend the plants in the background to basically reduce them to a backdrop against which the plumage of the birds stands out.

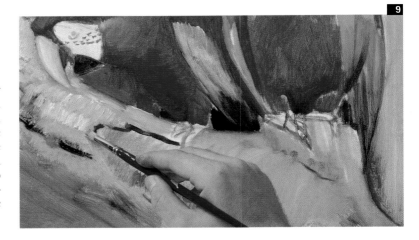

9 The trunk that was simply painted with a generic tone before, had to be modeled with grays (the way already indicated for the exercise with the statue), leaving the central portion to be painted with ochre.

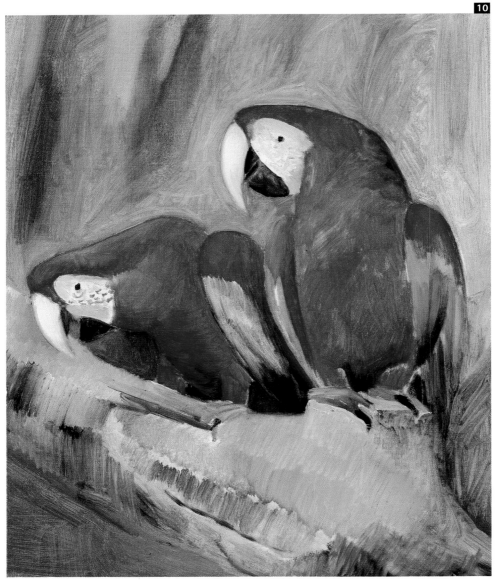

10 In the completed painting we can see that the background has been blended until it has been reduced to a backdrop or background tone with no details. This way, the vibrant tones of these tropical birds stand out in all their glory.

Value Study of a Landscape

To speak about value studies is another way of talking about modeling. Value work consists of creating three-dimensionality using color contrasts. If previously we worked on modeling with only gray, and later modeling with color (noting that it was more a matter of pure contrast than color gradation), now we will see the technique of creating contrast using several colors. Each one of them is shaded and modeled to offer a volumetric result. The subject chosen is a landscape, the view of a town. A theme that is characterized by the presence of all types of solid shapes and that favors contrasting colors to build up the composition that we will develop here.

This town built on a rock is the ideal subject for a painting based on contrasts. There are no areas of intense and saturated color, nor can it be said that the scene presents even coloration. There are very different tones involved that must be resolved by finding those that go well together.

MATERIALS
- Canvas
- Charcoal
- One heavy-duty medium-size brush, and two medium-size flat brushes
- Complete range of colors

1 The charcoal drawing is, in this case, quite detailed and records the houses as well as many of the door and window openings in them. Each area is carefully indicated using simple lines.

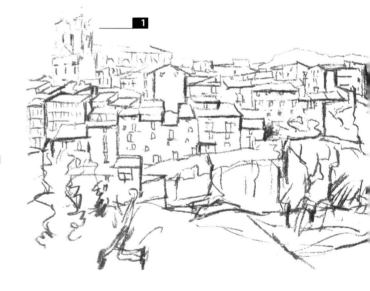

ROCKS AND ARCHITECTURE
The combination of rocks and buildings is always picturesque and full of possibilities. Rocks are a type of natural architecture in their own right that provides contrast and at the same time creates harmony with the man-made architecture of the houses.

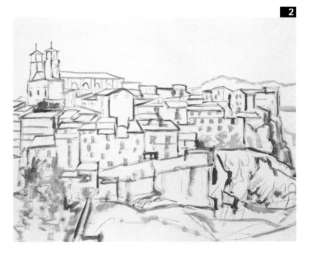

2 After eliminating the excess charcoal with a rag, the drawn lines are retraced with paint that has been diluted quite a bit. In this case, carmine has been used. This operation, done with the tip of the brush also suggests the shadows on the trees.

THE SUBJECT OF WHITE COLORS

In an oil painting, the areas that are completely white, of a pristine white, tend to appear harsh and lacking expression. If it is necessary to keep them in that color, it is recommended that the white be broken with a different tone, even if added in small quantities.

The Progress of the Composition

We know that an oil painting should develop as a whole, without elaborating some areas more than others. This is a good opportunity for finding out how this is put into practice. One area must be painted, passing immediately to the next, keeping the overall effect in mind at all times. Each brushstroke alters the general appearance, and something that seemed well planned at the beginning of the project may appear wrong now. In fact, it is a process of constant correction. If the working of the sky is too elaborate, it will appear incoherent with the rest of the composition and it will need to be touched up. If a color seems light, it will appear darker if an even lighter color is added, etc.

The evolution of an oil painting can be understood as a process of constant adjustment of color and shape.

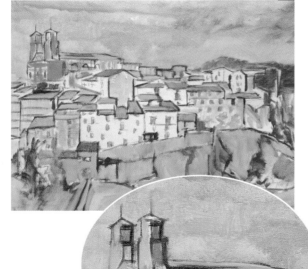

3 During the underpainting of the canvas, the dominant tone is somewhere between ochre and sienna, which will appear in most of the colors of the theme. We can see how the sky has been created with dabs of yellow and carmine. The result is reminiscent of a watercolor due to the abundance of solvent in the color mixture. Those two colors must be integrated in the overall tonality of the sky by working with the thicker one.

4 The siennas of the initial tones have been reinforced with darker shadows that make the volumes of certain prominent buildings, such as the church, stand out. For some of the houses, the white of the canvas has been used to preserve the luminosity of their color. These whites will be shaded later to soften their raw appearance.

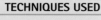

TECHNIQUES USED

- ◆ Preliminary drawing ◆
- ◆ Underpainting ◆
- ◆ Modeling with color ◆
- ◆ Color contrast ◆
- ◆ Value ◆
- ◆ Constructive brushstrokes ◆

5 In this picture, we can see how the initial colors of the sky (very diluted with solvent) are contrasted with different shades of blue, pink, and light yellow. Representing the subject matter with shades of different colors is a true value study.

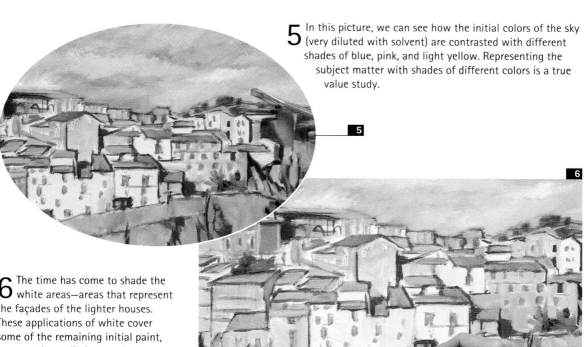

5

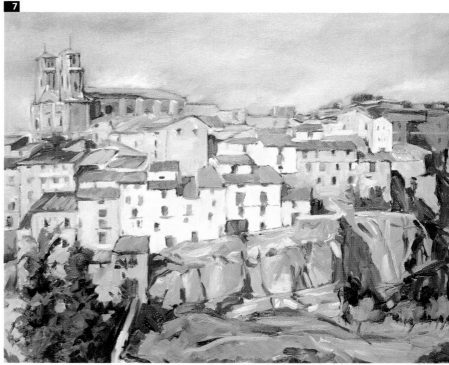

6

6 The time has come to shade the white areas—areas that represent the façades of the lighter houses. These applications of white cover some of the remaining initial paint, because the preliminary color applications were very fluid. This restores the pureness of the whitewashed façades, in great contrast with the rest of the colors.

7 This shows the finished work. It has been quite a labor-intensive job but the result is very rich in shades and color. The colors, which aside from the contrasts of the greens and the blue of the sky, are restricted to a series of chromatic modulations within a similar tone.

7

THE BLUE OF THE SHADOWS
Impressionist painters discovered that shadows have a bluish tone; thus, they achieved an incomparable coloration in their paintings. Whenever possible, blue should be used (mauve, light violet, and similar colors) for the shadows of the landscape.

Color Impastos

The following artistic process is produced with color impastos, that is, with a gradual accumulation of paint, which will add richness to work previously done in a regular manner. Impastos can be applied from the very beginning of the process with a palette knife or with thick brushes, but it is more common for the artist to apply the paint little by little, following the logical rhythm of the subject's representation. It begins with very diluted applications and the brushes are charged with paint as the chosen subjects become more defined. Working this way, the initial tones serve as a firm guideline to increase the density of the color.

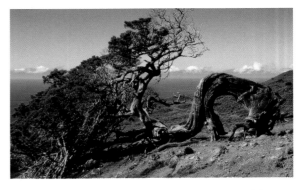

A landscape like this one, dominated by the shape of the tree in the foreground, can hardly be executed with a palette knife. The details of the branches and the complex combination of light and shadow require working with a brush, which is used for more precise and detailed work. The impasto should be created during the intermediate stages of the work.

MATERIALS
- Canvas or canvas panel
- Charcoal
- Fine, round brush
- Two medium-size flat brushes
- Complete range of colors

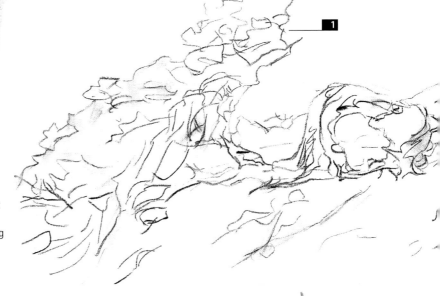

1 The initial charcoal drawing must address the main features of the branches and the foliage, by arranging the essential masses of the tree (the trunk and the top) proportionally to the format of the canvas.

2 The outlines marked by the charcoal drawing are retraced with a fine, round brush and a dark color, which can be carmine mixed with a small amount of ultramarine blue. After this, the true painting process can begin.

TECHNIQUES USED
- ◆ Preliminary drawing ◆
- ◆ Underpainting ◆
- ◆ Modeling with color ◆
- ◆ Impasto ◆

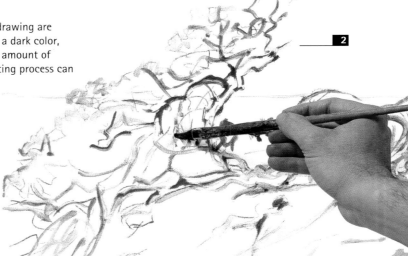

THE PROCESS BEFORE THE IMPASTO

Unless you are working with a palette knife, the painting process always begins by covering the canvas loosely with paint and by gradually defining the color. Once the chromatic relationships have been established, the artist can begin applying as much paint as needed with thick brushstrokes based on the previously created tones.

3 Preliminary underpainting: the two large areas (sky and ground) are blocked in with paint that has been very diluted with mineral spirits. The sky is ultramarine blue slightly lightened with white. The ground, including the tree, is carmine, more or less dark depending on the color intensity of the base painting.

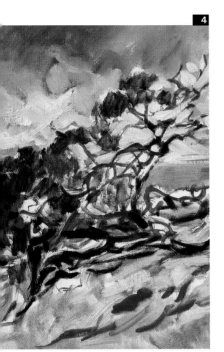

4 The particular color of each one of the subject's areas is applied over the preliminary painting: greens mixed with sienna for the foliage, ochre for the light areas of the terrain, burnt sienna for the dark areas, and dabs of blue mixed with sienna to suggest the more intense shadows. The sky is created with shades of ultramarine blue mixed with white. The color must still be very diluted.

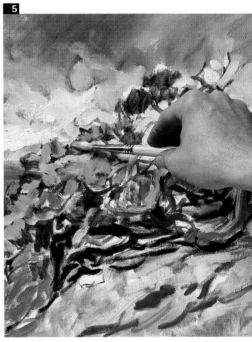

5 Impasto can begin to be applied over the previous color scheme. A medium-size round brush is used and the colors must be similar to the ones used for the preliminary underpainting, although they should be shaded with new mixtures to give the composition a vibrant color. The paint is applied without mixing it with mineral spirits.

6 Notice here how the work looks after the first application of paint with the brush. The colors are much richer and each brushstroke adds a new shade to the distant areas of the composition.

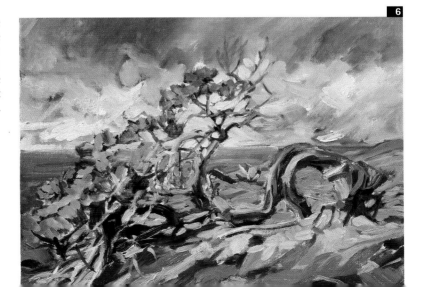

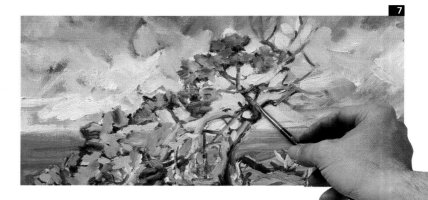

DABS OF COLOR
During the impasto, the layer of paint becomes gradually thicker as new brushstrokes of dense color are added. It is important not to drag the brush so the adjacent colors do not become muddied by the brushstrokes. Each one of them should be a dab of color applied to a specific area of the canvas.

7 Touching up can be done with a fine, round brush. This allows paint to be applied to small areas, for example, the spaces in the sky that open up between the complex twisting of the tree branches.

8 The final result is a painting with rich colors and generous texture, which is achieved through the accumulation of brushstrokes of colored paint. They add interest to the color without muddying it with excessive mixtures.

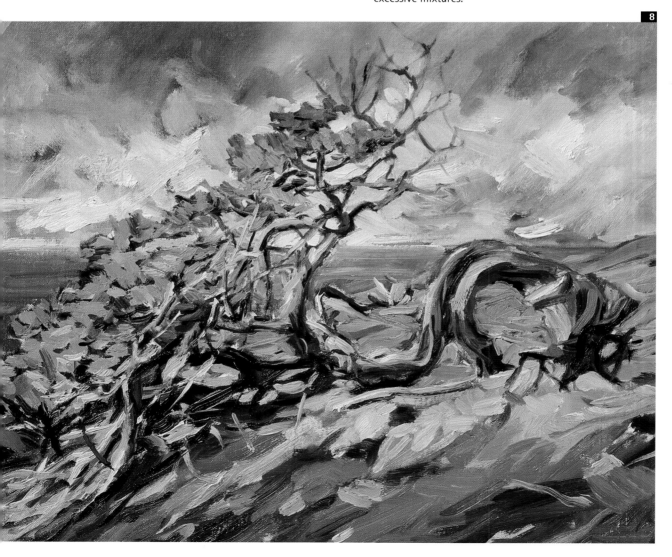

The Importance of the Brushstroke

The brushstroke is not only a way to apply color but also a true expressive resource. The shape, size, and direction of the brushstroke can define the figure as much as the drawing does or even more, especially when the painting style is energetic and quick, where the underpainting and the definition of color and form are done almost at the same time. During the initial stages, the brushstroke lets the artist create an effect of unity very quickly, particularly in themes such as the one in this exercise. The leaves on the flowers can be suggested very quickly with loose brushstrokes, which give way to precision work of contours and colors.

A subject with many details, which can be executed in a simplified way by using brushstrokes to build the shape of the composition. This initial simplified way can be developed later using conventional oil painting methods.

MATERIALS
- Canvas or canvas panel
- Charcoal
- Medium-size brush, two medium-size flat brushes, and a palette knife
- Complete color range

1

1 This is the preliminary sketch done with charcoal. Notice how the sketch corresponds only to the pot of flowers. The background is left unfinished because the entire composition of the leaves that form the background will be created with improvised brushstrokes.

2 After erasing the charcoal with a rag and retracing the most important lines with very diluted oil paint (carmine in this case), the background is painted. A larger brush, loaded with ultramarine blue, is used for this painting process, to create the shapes of the leaves at the same time that the background color is applied.

TECHNIQUES USED

◆ Preliminary drawing ◆
◆ Underpainting ◆
◆ Contrast ◆

2

The Direction of the Brushstroke

◆

Brushstrokes can suggest the shape in addition to color. Their shape and size determine the final appearance of the painting.

◆

When paint is applied on the canvas with loose brushstrokes that suggest the forms while we apply color, it is important to avoid applying all the brushstrokes in the same direction. The resulting effect will be similar to a combination that distorts the subject matter instead of constructing it. It is a good idea to apply the strokes in every direction; this will help avoid monotony, and very different forms will be created, so the composition does not look too repetitive. Remember that these brushstrokes should never be applied with dense paint because this would later pose a problem.

THE MORE GREENS THE BETTER
Monotony is sometimes the problem with the color green. All greens look similar and form a compact mass of color. Do not fall into this trap; take some time to look for different combinations.

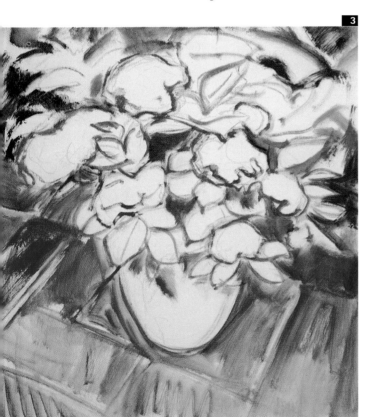

3 The entire composition has been quickly covered with paint with the larger brush and one of the flat brushes, but not the conventional way, using washes of very thin paint, but with brushstrokes that establish the color while suggesting the shape of the leaves in an interesting way.

4 After applying color to the area of the pot with flowers and leaves, we see how the applications of blue are in harmony with the deep greens of the background. Greenish tones are applied in the gaps left by the brushstrokes, which convey the appearance of foliage without representing the leaves literally.

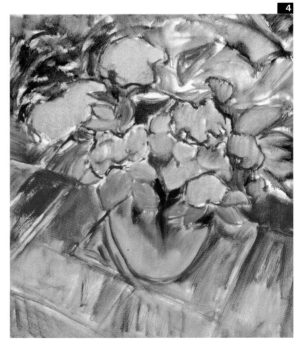

THE SIZE OF THE BRUSH
When the artist wants to paint with loose brushstrokes, brushes that are too small should be avoided because they are uncomfortable to handle and produce mottled results that are not very attractive.

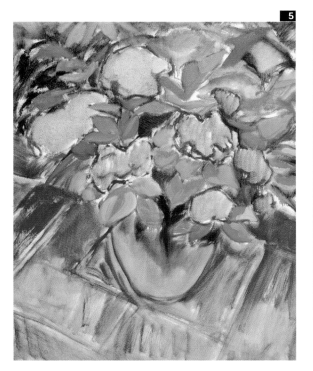

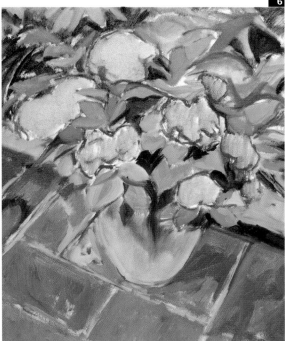

5 The silhouettes of the leaves that begin to appear in the background are created with loose brushstrokes of green that are quite diluted with mineral spirits. Thanks to that solution, the tone mixes with the blue of the background creating new shades of very dark green that enhance the feeling of thick and dark foliage.

6 It is interesting to compare the preliminary painting done with very diluted paint with the others that have a more solid, denser color. The first ones blend with one another (like the background or the pot), while the second ones maintain the integrity of the shape previously defined by the drawing.

7 The color of the floor's tiles, which before were simply a network of brushstrokes, now have acquired some solidity thanks to successive applications of thick color. This color is made using burnt sienna and red, with some touches of ochre. It is very important that all the brushstrokes that cover the floor are not the exact same color. The slight variations of tone make the color combination richer and give the composition some credibility.

When the Paint Thickens

As the work progresses, the paint becomes thicker. When the paint is too thick, caution should be exercised when superimposing very different tones because there is the risk of muddying the other colors. This is one of the typical risks of oil painting, which can be avoided by not adding tones that are very different from the ones already painted. Also, the base color can be scraped off with a palette knife to apply other tones over a base that is not as thick .

8 The thick brushstrokes of paint applied to the floor tiles can now be smoothed with the palette knife. A special texture is created when spreading the paint, especially if it is applied in one direction. That texture works very well for the area of the tile, so much that the paint applied with the palette knife is reminiscent of the tile's unique texture.

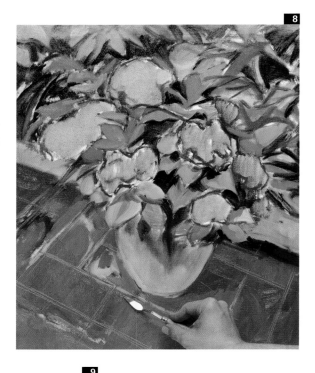

MODERATE USE OF THE PALETTE KNIFE
The palette knife quickly becomes addictive and if you are not careful you will find yourself using it everywhere in the painting for the pure pleasure of handling it. It is acceptable to create some definite effects with it as long as you do not abuse it.

9 Thanks to the palette knife, the floor can be considered practically complete. At this point the work is totally in harmony. Each one of the elements fits within the composition, and the brushstrokes that were spontaneous before are taking shape little by little.

THE RICHNESS OF THE PAINT

A dab of evenly applied pink paint is not the same as a dab made up of different shades of pink. The latter is much more interesting from every angle; therefore, the artist should never be satisfied with a single tone for each object.

The richness of the color is always an added value for any figurative representation, no matter how realistic it may be.

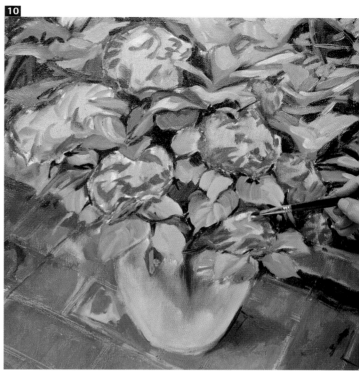

10 We can see here that the initial brushstrokes are especially useful for guiding the work. The areas of color that are almost abstract now make it possible to calculate the position and the size of each leaf as well or better than a very precise drawing would.

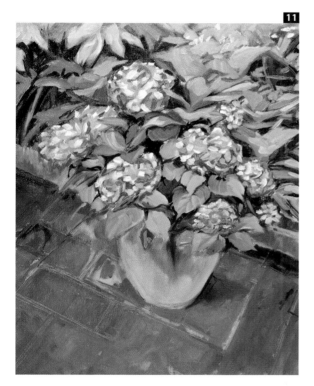

11 The detailing of the flowers has been left until the end, because their shape and color were already defined and they did not need much elaboration. But now, with the entire leaf composition at a very advanced stage, is the moment to model the petals by working them with the same pink (carmine plus red) as before, modeling them with dabs of carmine.

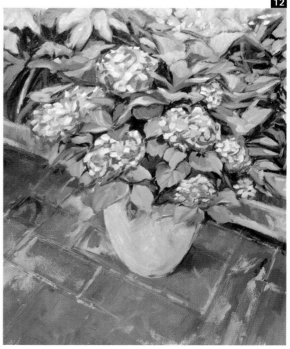

12 The treatment for the flowers consists of a number of short strokes, almost dabs of the brush, using the same pink with more or less white. In the darker areas, this color resembles unmixed carmine.

The Final Mixtures

In the last stages of the painting it is almost simpler to mix the paint directly on the canvas than to do it on the palette. The amount of paint accumulated on the canvas allows us to add the tonal nuances and mixing "in situ." For example, to lighten the carmine color it is not necessary to mix carmine and white on the palette, instead, a few white brushstrokes can be applied over the carmine that is already on the canvas. This way you will avoid an excessive accumulation of paint and the risk of not succeeding with the desired color, thus ruining the result. Normally, the mixtures made on the canvas during the last stages of the work are done with the brush well charged with paint.

◆

In the final stage of a work, it is easier to mix the paint directly on the canvas than on the palette.

◆

FROM THICK TO THIN
In applying the general principle for the use of brushes for painting with oils, we would say that the initial brushstrokes (or washes) can be as wide as desired, but the last stage of the painting should be executed with medium-size or fine brushes.

13

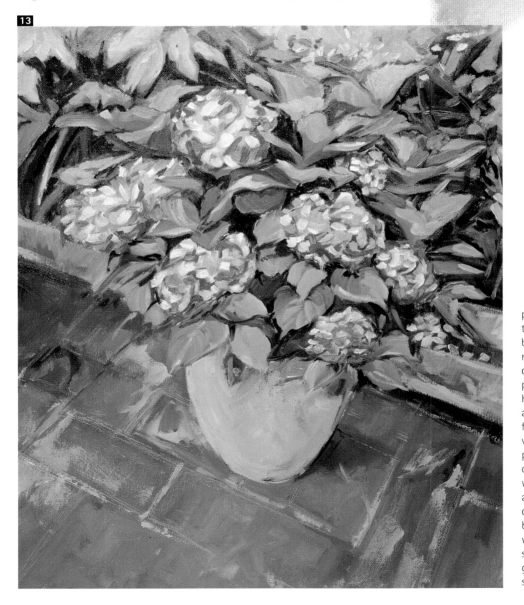

13 This is the completed project. Observe the leaves of the background and notice how the details are very prominent. This has not been achieved by following a very precise preliminary drawing, but with a quick and flexible distribution of brushstrokes, which have served as a guideline for the subsequent work.

An Atmospheric Effect

With all the knowledge acquired through practice up to this point, you are ready to tackle various effects that can be created with oil paints. One of them is the atmospheric effect, the diffused look of shapes and the colors created as a result of the effects of the air and the humidity suspended in it. This subject is a clear case of atmospheric landscape, a composition with fog. This fog, interposed between the components of the landscape and the viewer, can be created with the procedures studied up to this point, and adding some typical resources of oil painting.

This painting constitutes a subject of great interest for any artist who is looking for expressive effects in nature or a fugitive aspect of light, the sky, the climate, etc. The fog covers half of the panorama dissolving the farthest features in a whitish mist, which is the effect that this exercise seeks.

1

1 There is no preliminary drawing here. The landscape is sketched directly with the brush and paint, very diluted with mineral spirits. The color is sienna slightly mixed with green and applied to the canvas as if they were watercolors, using large brushstrokes. This way, the atmospheric approach of the work becomes clear from the very beginning.

MATERIALS
- Canvas or canvas panel
- One fine round brush, two medium-size flat brushes, and a palette knife
- Complete range of colors

THE COLORS OF THE PALETTE
This is the combination of colors used in this work, a surprisingly ample range given the nature of the subject. Among the colors there are three yellows: lemon yellow, medium cadmium yellow, and yellow ochre; two reds: medium cadmium red, and carmine. There is also cerulean blue and ultramarine blue, permanent green and emerald green, and finally, the earth tones burnt sienna and burnt umber.

TECHNIQUES USED
◆ Underpainting ◆
◆ Modeling with color ◆
◆ Value work ◆

The Atmosphere

◆

The atmosphere reduces the intensity and the contrast of the colors of the landscape.

◆

The atmosphere is one of the typical characteristics of landscape. The effect of the interposed air lightly diffuses the distant shapes and reduces the intensity and contrast of their colors. In this hazy landscape, the atmospheric effect is multiplied at the same time that medium ground is loosely represented, and the background disappears completely, concealed by the low clouds. The atmospheric effect of this landscape can be represented easily by reducing the color to a minimum, turning the shapes of the trees into "ghostly" silhouettes and avoiding representing the contours with precision. The effect of such a dense environment is very picturesque, and it suggests the landscape without showing it; we know it is there, but we cannot see it.

A THOUSAND AND ONE GRAYS
This is an ideal subject for inventing different mixtures of gray, grays tending toward ochre, bluish, greenish, earth tones, etc.—one thousand and one grays that form part of the dense fog that covers the forest.

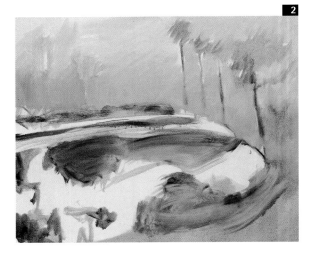

2 With the exception of the middle area, the rest of the composition is covered with a grayish tone, a product of mixing the previous sienna with white. Keeping in mind that sienna was modified by the green, the color of this new tone will vary according to the bigger or smaller proportion of that color in the mixture.

3 This work is done quickly and simply. A round brush is used for the application of the paint, defining the tones and the shapes at the same time. For example, in this picture we can see how using a brush charged with emerald green paint mixed with burnt umber, the trees are painted over where they had been sketched with paint.

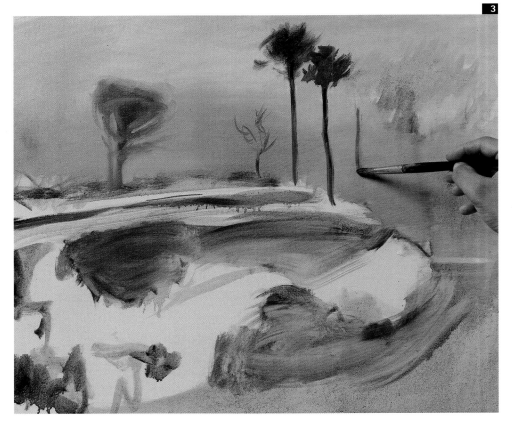

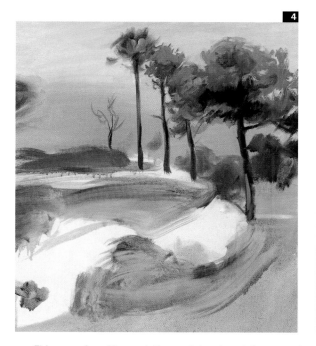

PAINT MIXTURES

In the photograph below we can see the mixtures made on the palette up to this point. The pinks are a mixture of sienna and white, to which a little bit of red has been added. Those pinks can be seen in the painting in the area that corresponds to the horizon, just below the middle ground. Also, different combinations of raw umber and blue, which correspond to the darker areas of the rocks, can be seen.

4 This way of working, painting and drawing at the same time, produces very interesting results. The trees all have a very similar color although tonal variations can be seen on the treetop and trunk, due to the distinct presence of sienna and green.

5 The secret of the representation of this foggy scenery resides in the intensity of the color of the most distant trees, which is created by mixing the colors with a larger amount of white so that their silhouettes produce less contrast with the background.

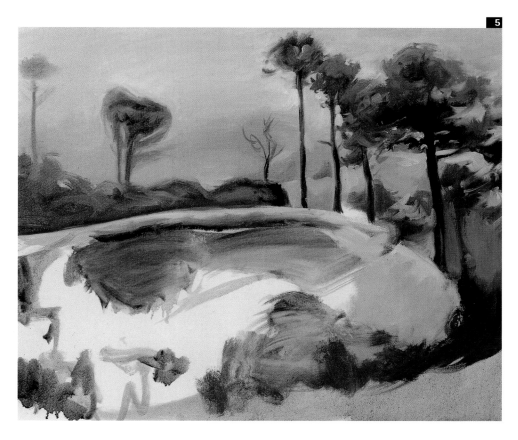

When the Shapes Lose Their Outlines

In a landscape, trying to get an exact outline for each form is an impossible undertaking. The bushes, the brush, and a good portion of the vegetation are all mixed in and lose their outlines when they are integrated in the background. This happens especially in this landscape submerged in fog. The best way of representing these forms is to apply a dab of paint with the brush, step away from the canvas, and check the effect of the dab. It is most likely that the first dab will not be the best one and it will have to be touched up with several more brushstrokes. The artist will step away again to see how it looks, and so on until its shape and color are integrated in the composition of the landscape. Working in this impressionistic way, the effects created can be very naturalistic.

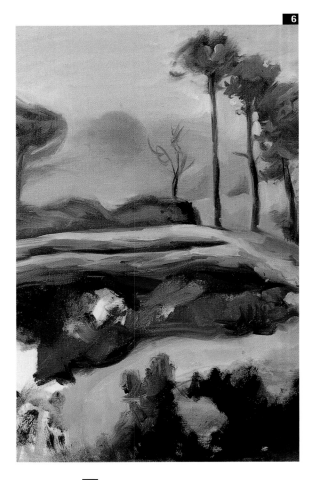

6 The direct and almost crude way of working this painting gives very good results. The applications of color in the center of the rocks begin to suggest the peculiar dimensionality of the landscape, and the colors used maintain a coherent relationship among them, always within a somber and muted coloration.

7 With a green lightened quite a bit with white, the brushstrokes are superimposed to suggest the shrubbery that grows on the rocks. They are quick brushstrokes that shape the shrubbery while they shade the color. The paint has to be quite thick to avoid mixing it with the preliminary base painting and confusing it with the base coat.

AERIAL OR ATMOSPHERIC PERSPECTIVE

This is the name given to the diffused effect caused by the atmosphere. This effect is easy to see during a sunset or a sunrise. But in subjects like the one in this exercise, altered by the mist, the aerial perspective is much more noticeable. Diffusing the colors and outlines creates a powerful sensation of depth, and from that comes the name of the perspective applied in the landscape.

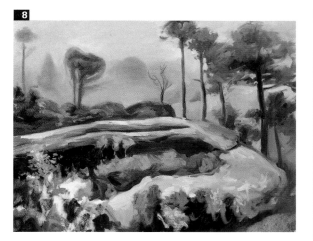

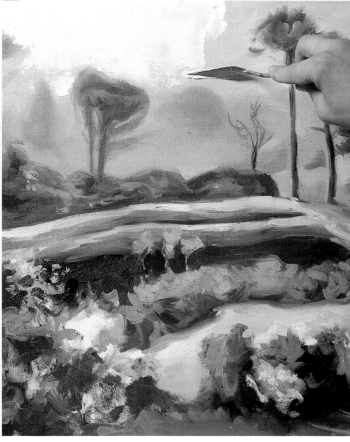

8 More shrubbery has been painted in the foreground, where these plants have bright yellow flowers. To highlight that yellow to the maximum, a good amount of very thick paint is applied. This way, they do not end up getting mixed in with the dense brushstrokes of the background.

9 Since the colors of the composition have a consistency that is quite dense, due to the peculiar treatment of the subject, the tones will have to be modified with undiluted, very dense, paint. This is what happens with the background; to lighten it, pure white is applied with the palette knife. These applications are mixed with the background color, after which they have a very light tone but not completely white.

THE COLOR OF THE FOG

Fog obviously has no color. Its presence is put into play by making the outlines and the elements of the landscape disappear. Therefore, to achieve a good representation of the fog, the outlines as well as the paint should lose their definition. Having said that, it should be mentioned that fog could be represented with light grays of different tones.

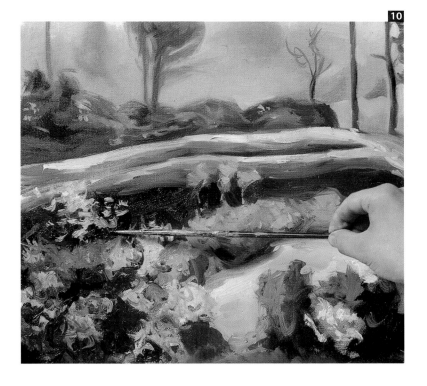

10 We go back to the flowers of the foreground. To make their tone stand out, the brush is refilled with pure yellow and the flowers are traced repeatedly trying to create their characteristic shape by applying paint dots.

Impastos and Color

The less varied the range of colors in a painting, the easier it is to apply impasto. A painting with a lot of different colors that contrast with each other cannot have too much accumulated paste because there is the risk of mixing the colors together. Using dense color always carries that risk; it is very easy to go beyond the boundaries of one color and invade another placed nearby. But when painting with a very limited number of tones, as in this case, impastos can be created without too much caution because the colors are similar and do not show "contamination" with other tones.

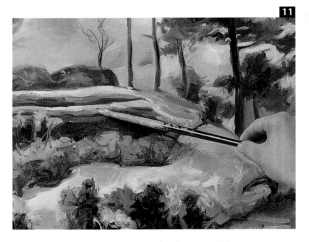

11 The tonality of the rocks is created by working the undiluted paint with the tip of the brush, to give them more volume and three-dimensionality. The edges are lightened and the shape is modeled with the same range of colors—burnt sienna and burnt umber mainly, lightened with white in the lighter areas.

12 This picture shows the final results. It is characterized by the abundance of impastos. The color has been used with very little solvent and this can be appreciated in the density of the modeling. The foggy effect, the interposed humid atmosphere, has been successfully achieved.

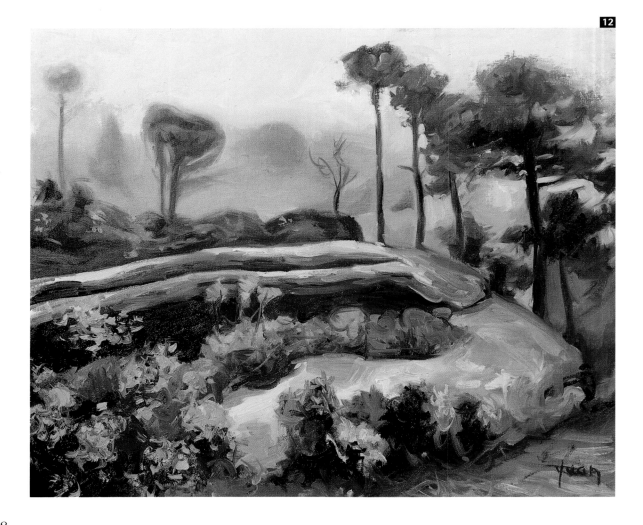

Modeling with the Brush

To conclude this series of exercises we will review a theme based on the human figure. The challenges that this type of painting may present are: the resemblance to the subject matter and the color of the skin, but in this area, both points become secondary because the thick brushstrokes take center stage. They create the general outlines of the shapes. This will be the basic factor used in this type of painting. As far as the figures are concerned, their size is so small and the clothing they wear is so loose, that their treatment will be similar to the one used for painting landscapes, without the need to resort to anatomical additions or special attention to the color of the skin.

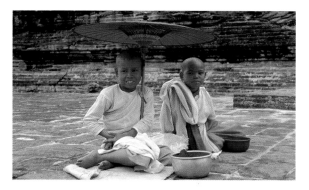

This exotic scene constitutes the subject of this exercise. An attempt is made to resolve all the factors involving form (color, modeling, etc.) with thick brushstrokes.

MATERIALS
- Canvas or canvas panel
- One round brush, two flat brushes, one medium-size brush, and one large brush
- Complete color palette

1 The initial drawing has been sketched with watercolors. A very diluted raw umber is used that is very dissolved to draw the overall composition, letting the brush flow freely on the surface.

1

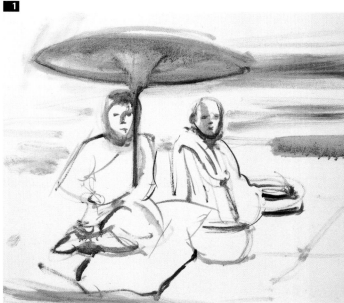

2

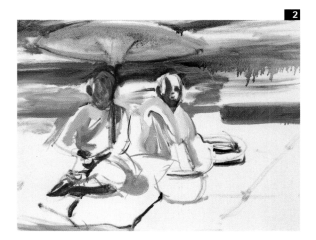

2 The canvas is quickly brushed with paint, using the large flat brush, and a series of colors generously diluted in solvent. The robes of the figures are covered with light pink and blue tones, while the upper area of the scene is painted with raw umber. Notice the dripping caused by the diluted color.

THE PALETTE
This is the distribution of the colors on the palette. Because this selection is more limited than the ones used before, the colors are spaced farther apart. This palette is made up of lemon yellow, cadmium yellow, yellow ochre, vermilion, cadmium red, sky blue, ultramarine blue, and raw umber.

The Size of the Figures

When subject matter contains human figures that do not fill the entire composition, the problem to be solved is how to communicate the expression when working in such a confining space (the space occupied by the heads). The problem is solved by reducing the faces to a minimum with the application of a few simple touches of the brush to indicate the positions of the eyes, nose, and mouth. If the face does not look good at the beginning, it is scraped off or cleaned with a rag and repainted. Once the face looks good, it does not need to be retouched because then it would be ruined.

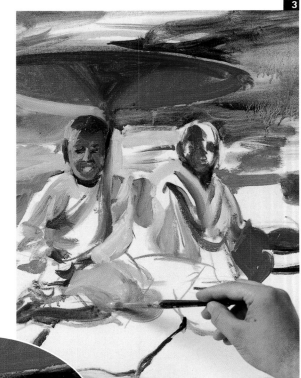

3 The first contrasts of the clothing are created by applying areas of warm colors (oranges and pinks), which create the first three-dimensional impression, without defining the shape perfectly. These first blocks of color create a general structure of the complicated array of folds and wrinkles that form part of the tunic.

4 A light tone is applied over the dark wash in the background, unifying the colors. The previous colors, very diluted in solvent, darken the white to create an intermediate tone, which is the appropriate one for this area of the composition. The upper bodies of the figures have been created, for the time being, with brushstrokes of a color similar to that of the background, but shaded with light touches that suggest the facial features.

TECHNIQUES USED

- ◆ Preliminary drawing ◆
- ◆ Underpainting ◆
- ◆ Modeling with color ◆
- ◆ Value work ◆

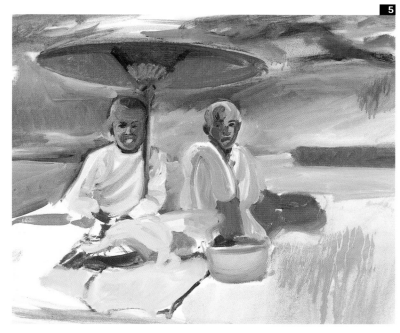

COOL AND WARM COLORS

This painting offers a good example of the effect produced by the contrasts between warm and cool colors. Warm colors, such as pinks and yellows, which dominate the figures, always tend to move closer to the foreground, while cool colors tend to distance themselves. It is a very useful factor when it is a matter of making the figures stand out from the background, as in this case. The background colors can be touched up so they acquire a much cooler tone than the figures.

5 Painting progresses rapidly. Now the cool tones are visible (grayish blue), located behind the figures. The contrast of the warm tones of the clothing with the cool color of the background promotes the spatial feeling of the scene.

6 The contours of the folds, previously created with wide strokes, are outlined with a fine brush. These new applications highlight the shadows and the lines between the folds and define the details of the scene.

7 It is interesting to see how the forms are shaped with simplicity, without repeated touch-ups, using wide brushstrokes that suggest the volume. Notice for example, the bluish container.

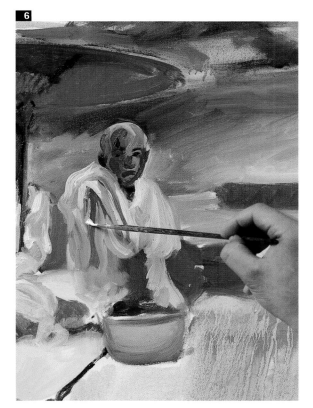

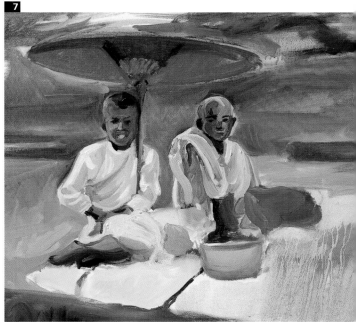

Neutral Colors

We know that among the varied ranges or families of color are those known as neutral colors, "dirty" colors that can be cool or warm. They form a range as wide as the artist wants it to be, because a new neutral color can be created from two previously mixed ones. This is what has to be done to represent the color of the ground: The palette fills up with ochre, sienna, and gray tones, and with each new mixture a new possibility is created that can itself be mixed with the previous tones. Naturally there is a limit; colors get progressively darker and one must stop before the composition becomes too dark.

THE MIXTURES
The palette shows the mixtures created so far. Brown tones, because of the raw umber, dominate the palette. Blues and pinks, which constitute the colors of the clothing, can also be appreciated. Parting from the colors mixed until this point, the painting will progress by repeating these basic tones.

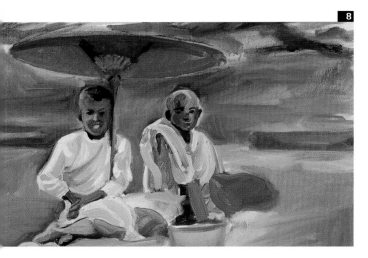

8 The entire canvas is now covered with paint. The colors of the ground and of the background are very similar and they will have to be differentiated by making the surface of the ground more interesting. On the other hand, because the entire canvas has been covered with brown tones, the figures now stand out much more as a result of the light tones of their clothing.

9 The modeling of the clothing continues, using long brushstrokes that follow the waviness of the folds, alternating pink and blue and darkening the shadows very slightly so the composition does not lose its light and soft coloration.

THE PARASOL
The parasol is red, simply cadmium red. There is no need for other shades; this color is enough to give the shape and should not be altered with any other colors.

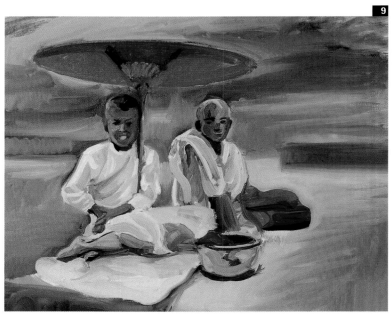

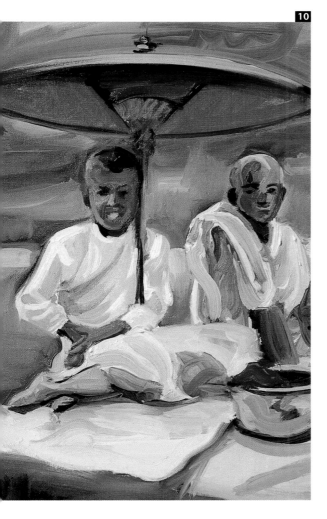

10 The contours of the parasol, which were red up to this point, are outlined with a few strokes of undiluted raw umber. These contours give the parasol a feeling of solidity while they reinforce the simple structure of the composition. This is the moment for working the ground by applying white brushstrokes that mark the separations between the stone slabs.

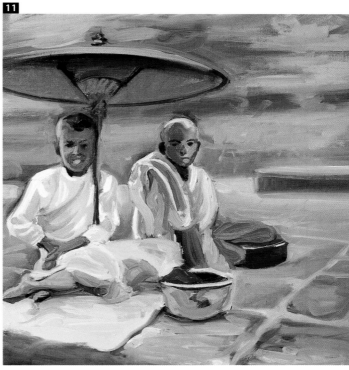

11 The details of the slabs on the ground are visible now. The same colors as those of the base (raw umber and ochre) will be used, but applied with loose brushstrokes to give texture and to suggest the roughness of the stone.

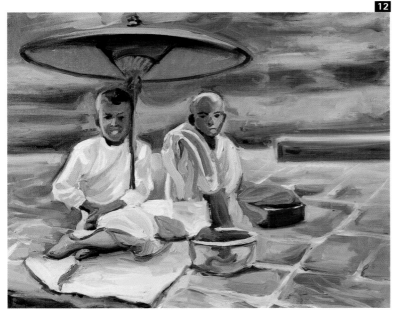

12 The detailing of the ground is now extended to other surfaces, such as the container in the foreground, which is modeled with dabs of unmixed blue over the previously applied paint.

Time to Finish

It is better to leave the painting unfinished than to overwhelm it. In the first case, there is always a chance to finish it some other time, but in the second case, it is too late. It is not easy to know when to lift the brush off the canvas and to consider the painting completed, but a basic guideline can help you make that decision: When you do not know how to improve the composition's effect, you should choose to put it to rest. Every project can be improved, but it is better not to try it if it is not clear how you are going to achieve that. The painting should be left to "rest"; it must be forgotten for a few hours or for an entire day to return to it with fresh eyes, at which point a more objective decision can be made.

13 The work on the slabs of the ground is almost finished. The edge in the foreground has been darkened and the composition has acquired a much more defined appearance. There is still work to be done in the space between the two figures, which are still somewhat undefined.

14 The end of the process is reached when the unrelated areas of color in the center of the composition are unified. Notice how shaping with the strokes of the brush has given this work a true artistic sense, which is in agreement with the nature of oil painting.

**Other books by this publisher
about oil painting**

If you want to study oil painting in depth,
in the following titles by **Barron's
Educational Series, Inc.** you will be able
to find all types of practical applications
of the techniques studied in this book.

Collections and Titles

Learning to Paint Series
- *Oils*
- *Mixing Colors, Oils*

All About Techniques Series
- *All About Techniques in Oil*

Art Handbooks Series
- *Oils*
- *Mixing Colors 2. Oil*

Easy Painting and Drawing Series
- *Painting Still Lifes in Oils*